HIDDEN
HISTORY
of
EVERGLADES
CITY

& *Points Nearby*

MAUREEN SULLIVAN-HARTUNG

Charleston — London

THE
History
PRESS

Published by The History Press
Charleston, SC 29403
www.historypress.net

Cover images: Front cover: Storter's General Store along the former Allen River, today's
Rod & Gun Club site, circa 1917. *Courtesy of the Florida State Archives*. Back cover, left
to right: aerial view of Everglades City taken at the Seafood Festival, 1994. *Photo by
author*; map of southwest Florida, 2010. *Courtesy of Patti Bailey, ci-Interactive*; Chokoloskee
pioneers Mamie and Ted Smallwood, with five of their six children, circa 1917. *Courtesy
of Chris Hancock.*

First published 2010
Second printing 2011

Manufactured in the United States
ISBN 978.1.59629.744.9
Sullivan-Hartung, Maureen.
Hidden history of Everglades City and points nearby / Maureen Sullivan-Hartung.
p. cm.
Includes bibliographical references.
ISBN 978-1-59629-744-9
1. Everglades City (Fla.)--History. 2. Everglades City (Fla.)--Social life and customs.
3. Everglades City (Fla.)--Biography. 4. Historic buildings--Florida--Everglades City. 5.
Everglades City (Fla.)--Buildings, structures, etc. 6. Everglades City Region (Fla.)--History,
Local. 7. Everglades City Region (Fla.)--Social life and customs. 8. Everglades City Region
(Fla.)--Biography. 9. Historic buildings--Florida--Everglades City Region. I. Title.

F319.E94S85 2010
975.9'44--dc22
2010038268

HIDDEN HISTORY
of
EVERGLADES CITY

& *Points Nearby*

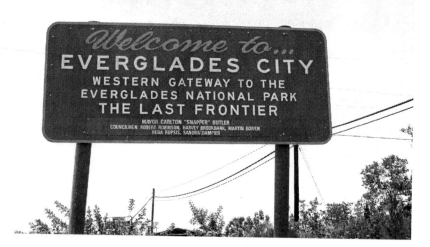

Welcome to Everglades City sign, 1994. *Photo by author.*

CONTENTS

CONTENTS

ACKNOWLEDGEMENTS

T here are *so* many people to thank for making this book possible—too many to name them all individually, but certainly several stand out who deserve special recognition. Thanks, first and foremost, go to my mother, Joyce Templin Sullivan, for instilling the love of reading in me and my sisters—all four of them: Annette, Kim, Colleen and Bettina. Thanks, too, to all of my other family members for their continued support during this writing experience.

To my patient friends, both near and far, who suffered along with me during all this researching and writing—while encouraging me all along—I thank you and I cherish our friendships. There are several people who have indeed gone above and beyond the norm. I'm indebted to fellow author Lila, not only for her assistance with the scanning process but also for some great images, as well. A new friend came into my life during this writing, and I am very appreciative of Alvin, not only for his friendship to me but also for his generosity in permitting me unlimited access to his vast collection of historical postcards. You're the best! Lindsey was a real dream to work with at the Florida Archives in Tallahassee. It was so hard to narrow down which images to use because there were so many wonderful old shots. Tom, a former deputy with the Collier County sheriff's office, provided me with some wonderful images and some colorful history, too. And Bob, from the Big Cypress National Preserve, was more than generous with his materials. It was hard to find a friend who didn't mind proofing and editing my work, one chapter at a time, because no one really wanted to see bits and

pieces. However, my longtime friend Susie-Q was waiting there for me and enlightened me on several matters—one even on dynamite! I am so very grateful to you and our twenty-year friendship. Thanks to Prissy, too.

For nearly two months, I scoured numerous websites trying to find a fairly nondescript map to be used in marketing my book; however, I kept coming up empty-handed, until I received a call from Patti, who was answering my e-mail request. Without even knowing me, Patti took on this map project and did not let up for a week until she finally secured one that was suitable for my needs. Job well done, Patti! Then, a last-minute request went out to Nancy, who came back the following day with an incredible image that I've included. My profound thanks to Tom and Paula for arranging my very first speaking gig—even before the book was published! Packing a decade's worth of information into a specific word count within a three-month time frame is very tricky indeed. Some people did not want to share their stories with me. Some simply did not return my calls. Some couldn't work within my deadline. I did the best I could with the materials and time I had available; however, I am very cognizant that this is but a sampling of the many wonderful tales of this area's pioneer families.

A *big* thanks to the wonderful residents of Everglades City and the surrounding areas who opened both their doors and stories to me for inclusion—especially Glenda and Chris from Chokoloskee. And Helen has been such a wealth of information to me—I've dubbed her my own historian. Words cannot express my gratitude for your willingness to assist me with this book day or night these past few months, but I hope you will accept my thanks. I found a wonderful cheerleader in Marya, another author, during the homestretch. And I also owe a debt of gratitude to the late Maria Stone, who passed in 2009 and who had encouraged me to write this book. I'm so sorry you aren't here to see my first book. Were it not for my fellow author, friend and subsequent mentor Prudy Taylor Board, who believed in me and gently nudged me into writing the query for this book, you probably wouldn't be hearing from me at all. Thanks Prudy—for everything. And another special note of thanks goes out to Jonathan, as well as the Tuffs. Thank you too, Squeek, for fourteen years of happy memories…I miss you so.

And thank you Jessica Berzon, my editorial assistant at The History Press in South Carolina, who has the patience of Job. And then there was the fabulous commissioning and production crew headed by Adam Ferrell and Julie Foster. It was also a pleasure working with Jamie-Brooke Barreto during

the marketing phase. And I'm also so very appreciative of my editor Ryan Finn's ability to keep my voice intact while making the seamless editorial changes that make my story flow more efficiently. Thanks to all of you for taking a chance with me on my first book and then walking me through it step by step throughout the entire publishing process with such patience and professionalism—even if we did get off to a rocky start with those images.

And finally, I want most to thank my loving and patient husband, Phillip. Not only has he been with me every step of the way—believing in me even when I didn't believe in myself—he's also carried my camera, driven me to interviews, trekked countless miles in researching, read and reread chapter after chapter and provided input. He has cooked many dinners so I could continue my dream of writing this book while also being my number one cheerleader for the past nineteen years. I couldn't have done this, Phillip, without your continued support. My life would be incomplete without him—he's both my knight in shining armor and my best friend. He makes me a better person.

History of the
Last Frontier

Welcome to Everglades City, Home of the Last Frontier

What comes to mind when you hear of Everglades City and its surrounding areas mentioned? You probably think of fishing and the Everglades National Park, because that's usually the response we hear, and those answers would indeed be correct. Perhaps even Barron Gift Collier, too, our county's namesake, if you've heard anything about the history of Collier County. And maybe you've even heard of the historic Rod & Gun Club that's been around for years, hosting both numerous dignitaries and former presidents. What I want to know, though, is whether you have ever heard about the Storter family, the Smallwood family or the Janes family? What about Mama Hokie or Frances Hodge? What about Totch Brown, A.C. Hancock, C.G. McKinney or Annie Mae Perry and many others who were also pioneers in this region of southwest Florida? They may not have the name recognition of Collier, but their lives have indeed been an important thread in the creation and development of this county.

As you cross over the Barron River Bridge, you find yourself entering Everglades City, touted as Florida's Last Frontier. Located forty-five minutes south of Naples, this former county seat has remained relatively laid-back and unpretentious, as in the "olden days." While fishing and tourism are presently the major economic factors of this small town of about five hundred year-round residents, the town has a colorful reputation and some

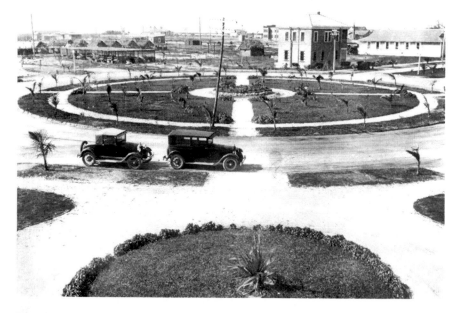

Historic Everglade Town Circle, taken from Collier County Courthouse steps, early 1930s. *Courtesy of Collier County Museum.*

very deep roots. There are numerous historical sites located within walking distance of one another with several situated around the town circle.

As you enter the town, you'll notice on your left the Seafood Depot Restaurant, which actually housed the former Atlantic Coast Line Railroad Depot that opened in 1928. Imagine passenger and freight trains coming and going from this rural spot and heading over to Immokalee during its heyday. Right on the town circle stands Everglades City Hall, the former Collier County Courthouse—until 1962. On the next block stands the former Bank of Everglades building that opened in 1923. Along the picturesque Barron River is the famous Everglades Rod & Gun Club, and across the street is the former laundry for Collier's company town that is today home to the Museum of the Everglades.

Clearly, one of the greatest assets of Everglades City today is its proximity to nearby Everglades National Park, which opened in 1947. This subtropical wilderness of mangrove coast, hardwood hammocks, pine forests, cypress swamps and sawgrass prairies is like no other in North America. From here, visitors can enter by boat the vast mangrove estuary of the Ten Thousand Islands. Narrated sightseeing boat tours allow you to get a closer look at

ospreys, pelicans, dolphins, bald eagles and, oftentimes, manatees. "There are no other Everglades in the world," wrote the late environmentalist Marjory Stoneman Douglas in her bestseller, *The Everglades: River of Grass*. It was Douglas who would bring the world's attention to this unique ecosystem, back in 1947.

Without question, Collier's incredible investment of both time and money have without a doubt put Everglades City on the map, and we are grateful indeed for his foresight into this once forsaken territory. I am happy to have you with me as you learn about Everglades City's history, along with that of its surrounding areas, which include Chokoloskee Island, Copeland, Lee-Cypress, Port DuPont, Ochopee and others. So, sit back, relax and enjoy your "armchair tour" of the Last Frontier.

BARRON GIFT COLLIER, COUNTY NAMESAKE

Certainly much has been written over the years about Barron Gift Collier—the genius behind the creation of Collier County out of this former remote wilderness—as well as his equally impressive desire and dedication in bringing the Tamiami Trail to fruition, which opened up southwest Florida for the masses.

Collier was born in Memphis, Tennessee, in 1873. Here was a man with vision. Here was a man with purpose. Collier had earned his first million from his successful streetlighting business. Then, moving into the printing and advertising industry, Collier began selling advertising card franchises to the nation's booming train, trolley and subway lines. His New York City firm, Collier's Consolidated Street Railway Advertising Company, led the market in mass transit advertising.

Collier had visited both Jacksonville and Tampa on business trips by early 1900; however, a railroad friend invited him to visit his personal retreat on Useppa Island, a barrier island located in Lee County, in 1906. Collier fell in love with the vast wilderness and over the next decade bought more than a million acres of land, including Useppa Island. On his first visit to "Everglade" (it wouldn't become "Everglades" until it was incorporated in 1953), he discovered a tiny garden spot on the former Allen River, today's Barron River, that left an indelible image on his mind. With his "master plan" for Florida in place, he purchased the Storter homestead, today's Rod & Gun Club. He then persuaded the State of Florida to create Collier

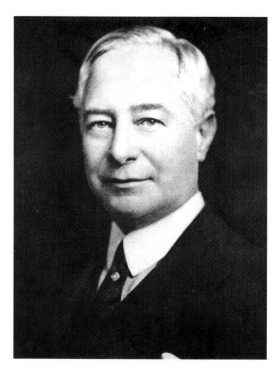

Barron Gift Collier, Collier County namesake. *Courtesy of Florida State Archives.*

County out of southern Lee County and then pledged to the state legislature he would complete the long-awaited highway between Tampa and Miami, today's Tamiami Trail, using his own finances. He established Everglade as the first county seat and then completed the massive road project in 1928, opening endless opportunities to Florida's Last Frontier.

While he lived to see this project to its fruition, as Florida's largest single landowner, Collier died on March 13, 1939, decades too soon to see his entire dream for Collier County fulfilled.

Over the years, I've had people ask me if "Gift" was indeed his middle name, and I've always been quick to reply in the affirmative—reminding them that he *was* the "Gift" to Collier County.

BUILDING THE TAMIAMI TRAIL: AGAINST ALL ODDS

While the Tamiami Trail, a 264-mile stretch of road in southwest Florida connecting Tampa to Miami, may have been a pipe dream back in the early 1900s; the finished road would take literally thousands of man-hours,

millions of dollars ($13 million to be exact) and several years to complete. This new road now made travel across the southern region of the state possible while also opening up numerous business ventures, as well as new home-buying opportunities. This vast construction project also led to the renaming of a large portion of land, in excess of one million acres, from Lee County to Collier County on May 8, 1923, after entrepreneur Barron Gift Collier vowed to revive the massive project using his own money. The longest and toughest stretch of the construction was the 76 miles from Naples connecting to the Miami-Dade County line, which officially opened on April 26, 1928, with a grand celebration.

With the advent of automobiles came the demand for modern highways, which forever changed the Florida landscape. Today, while traversing the Tamiami Trail on smooth, paved roads, it is hard to image the real blood, sweat and tears that were undoubtedly behind this incredible creation—it is often compared to the building of the Panama Canal. Picture, if you can, oxen on the Tamiami Trail hauling the necessary supplies of gasoline, fuel oil, dynamite and more to the crews working in unbelievable conditions. These conditions included scores of mosquitoes, hundreds of snakes, thousands of horseflies that would take a hunk out of their unsuspecting target, alligators,

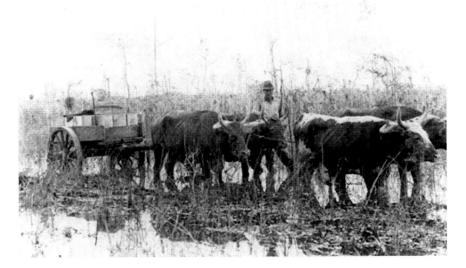

Oxen working on the Tamiami Trail construction, mid-1920s. *Courtesy of Collier County Museum.*

unbearable heat and endless water. Construction records in 1927 reported that twenty-nine oxen were either injured or killed, out of a workforce of forty that were available throughout the three-year project.

However, even before oxen could be used, other preparations were needed, including dredging the winding Barron River into a wide, deep waterway capable of handling oceangoing vessels. A canal had also been constructed up to Carnestown in order to connect with the canal on the East Trail, which would then enable bulk supplies and gasoline to be moved to the "front" (the focus of the construction) on narrow barges through this canal. This twenty-foot-wide, fifteen-feet-deep canal would provide enough fill to build the Tamiami Trail. The first step was to lay out the center line of the road. Machetes were used to cut the thick brush on this impenetrable terrain, and then stakes were driven into the ground every one hundred feet to mark the center of the road. Next the clearing crew came in to cut down all the trees, mostly using two-man hand saws, with the men oftentimes working in waist-high water in teams of two. These felled trees would then need to be dragged clear of the right of way by the various teams of oxen.

Dynamite would be a large expense—50 percent actually, of the construction costs. On the thirty-one-mile stretch between Carnestown and

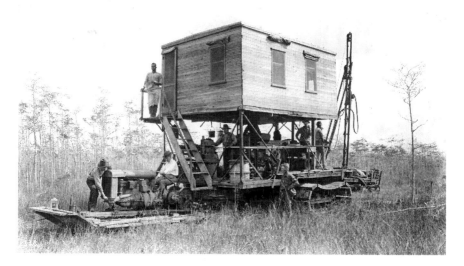

Drill rig used on the Tamiami Trail construction, mid-1920s. *Photo by William A. Fishbaugh. Courtesy of Florida State Archives.*

the Dade County line alone, nearly three *million* sticks of dynamite were used, resulting in a total completion cost of $8 million just on this one segment. One entire freight car load was used every three weeks during the three-year project, with the dynamite having been shipped from the factory to the Fort Myers railhead, where it was then transported by barge and stored safely. It would later be moved to the blasting sites by teams of oxen; however, if the muck was impassable for the oxen, the workers laid wooden rails down and the men themselves pushed the loaded car with the dynamite.

Under the capable direction of civil engineer David Graham Copeland (whom the nearby town is named after), a graduate of the U.S. Naval Academy at Annapolis, the construction crew worked round-the-clock in building the Tamiami Trail, beginning in 1925. And they employed state-of-the-art equipment necessary to complete this project, which included the drill rig. This thirty-ton piece of equipment drilled holes in solid rock and preceded the Bay City Walking Dredges. These dredges operated in tandem and employed a system of leapfrogging, averaging eighty feet per shift, while working two ten-hour shifts each daily. The Bay City Walking Dredge has been named a National Historic Mechanical Engineering Landmark and is currently housed in the nearby Collier-Seminole State Park that stands as

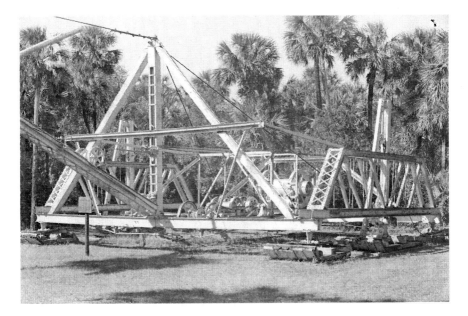

Bay City Walking Dredge used on the Tamiami Trail construction, mid-1920s. *Photo by William Z. Harmon. Courtesy of Florida State Archives.*

a memorial to the county namesake, Barron Gift Collier. Additionally, the Bay City skimmer was a precursor to today's bulldozer and was considered one of the most critical pieces of machinery used in road construction. It could level the pile of fill, doing the work of at least fifty men. The scarifier was also a "must" in the finishing process, with its fourteen-foot blade that held six-inch-square teeth made of steel that either broke up or brought to the surface the larger rocks, so they could be discarded. The rough grader would smooth out the surface so that the asphalt could then be applied to prevent erosion. It is said that the cost of building the Trail increased as they approached the Dade County line because they found themselves facing solid rock that required constant dynamiting.

Collier could most definitely be counted on to look after his workers. Not only did he provide them with portable bunk houses that moved along with the completion of the Trail as a working "camp on wheels," but they were also provided with nutritious meals. Fresh food and ice were brought in daily for those working on "the front" from the nearby commissary located at Port DuPont, four miles away from the road construction. Both venison and wild turkeys were occasionally purchased from local Indians as supplements. Mess attendants, mostly women, were permanently assigned to both prepare and

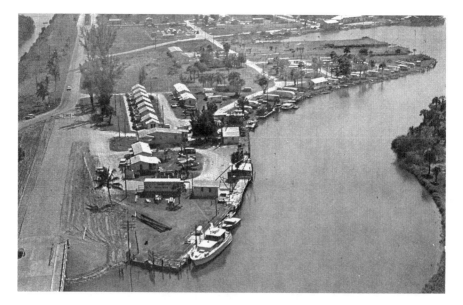

Port DuPont, working station for the Tamiami Trail construction. *Courtesy of Alvin Lederer.*

serve nutritious meals for this round-the-clock operation. Labor was indeed cheap back in the late 1920s, with common laborers receiving twenty cents per hour; those working at "the front" were paid sixty dollars per month.

Speaking of Port DuPont, it has been repeated over and again that without the port facilities and shops located here it would have been impossible to build the Tamiami Trail. Here at Port DuPont, Collier constructed an electric shop, a foundry, a large machine shop, a repair garage and a woodworking plant, as well as a shipyard. There were twenty highly skilled workers who could repair or rebuild any type of machinery used on the building of the Tamiami Trail at these important facilities, while working around the clock. H.L. Bristol, reporting for the *Collier County News*, wrote on April 26, 1928, about the influence that Port DuPont had on keeping the building of the Tamiami Trail on target: "Too much praise cannot be given to the blacksmith who on many occasions has stood over his forge all day and far into the night twisting, white hot iron into intricate shapes; the machinists who took these forgings and machined them to their required dimensions."

From an historical standpoint, the site that was Port DuPont was originally settled by a black man named August Swycover and his wife.

Parade following the official opening of the Tamiami Trail, April 26, 1928. *Courtesy of Florida State Archives.*

They raised sugar cane for shipment to Key West. Additionally, Collier built a church for his black workers in Port DuPont; it was dedicated in June 1927. Later that same year, a school for black students was built and opened with twelve students. The garage at Port DuPont serviced the Mounties' motorcycles as well.

The headline from the *St. Petersburg Times* on December 11, 1927, stated it best: "Modern Highways Cut 'Glades 36-Day Run to 24-Hour Drive." The article stated that "just four years ago a group of 'trail blazers' consumed 18 days in traveling through the Everglades to Miami. A scant few weeks ago an automobile left Everglade in Collier County, for Miami, and returned in a single day, traveling over virtually the same route."

At last, the opening of the Tamiami Trail was completed, and an official celebration was held, complete with band and a grand parade. A large motorcade of roughly five hundred cars that included Collier and other important luminaries departed from Fort Myers, arriving in Everglade before noon, when refreshments were served and speeches given. Afterward, the motorcade continued across the Tamiami Trail over to the Miami-Dade County line and continued on to Miami.

Maintaining Law and Order in the Last Frontier

After the establishment of Collier County by Barron Gift Collier in 1923, the formation and enforcement of law and order became necessary throughout the county's 1,276,160 acres that stretched from the Miami-Dade line eastward to the agricultural community of Immokalee. Dubbed the "Last Frontier" because of its sheer remoteness and proximity to the Ten Thousand Islands, this was a natural place for those hiding from the law.

While construction of the Tamiami Trail was ongoing, connecting Tampa to Miami, husband and wife teams were hired as the Southwest Mounted Police to maintain law and order and later provide services for travelers on the newly completed Tamiami Trail. They were stationed every ten miles along the Tamiami Trail from East Naples down through the Everglades and over to the Miami-Dade line. These motorcycle-riding members of the Southwest Mounted Police were later deputized and paid by the sheriff. Each deputy patrolled five miles on each side of his assigned station on a Harley-Davidson motorcycle, offering assistance to motorists in trouble, apprehending poachers

and enforcing traffic laws. Keep in mind, the very rough gravel roads were wide open and not heavily trafficked yet, and wild animals were also known to roam freely. Meanwhile, back at the individual two-story stations, where gas and snacks were sold, the deputies' wives remained to aid motorists with restrooms, food, fuel and a comfortable place to rest. The husband and wife teams would make their home on the second floor.

The six stations along this route included Belle Meade, at Routes 41 and County Road 951 (known today as Collier Boulevard); Royal Palm Hammock, at Routes 41 and County Road 92; Weaver, which was located opposite the Fakahatchee boardwalk and was demolished with Hurricane Andrew; Turner River, near Ochopee; Monroe, the remaining rest station, although boarded up; and Paolita, on the Miami-Dade County line, roughly ninety miles from Naples. Today, the Big Cypress National Preserve has ownership of the Monroe Station, with plans for its future restoration into an interpretive museum. Monroe Station is also listed on the National Register of Historic Places.

What about the other stations? What has happened to them? I was told that one was moved to Everglades City and converted into a house. One station was razed during a road-widening project, most likely Paolita. Two were destroyed by hurricanes: Weaver by Hurricane Andrew and Turner River by Hurricane Donna. Royal Palm Hammock remains standing today, even though it has lost its historical character. It is located near the entrance to the Collier Seminole State Park located along the Tamiami Trail. It was the largest of the six stations. In 1937, Meece Ellis and his wife took over the station and restaurant and later built ten cottages for rentals. Ellis was the operator of the Bay City Walking Dredge that helped carve out the Tamiami Trail. By 1934, the Southwest Mounted Police force ceased to operate; however, the Ellises continued to stay and run the station for thirty more years. The Weaver station was smaller than the other stations. It opened in 1928. Mr. S.M. "Red" Weaver ran the filling station. It was renamed Big Cypress Bend Station. The Turner River station opened in 1927 and was in use during the 1950s until Hurricane Donna finally destroyed it in 1960. Monroe Station was closed in 1931.

Unfortunately, two of these initial Southwest Mounted Police were killed in the line of duty. Deputy Sheriff W.B. Richardson, serving out of the Paolita Station, was killed in December 1928 while on patrol when his motorcycle struck a bridge guardrail. Then, the following month, just six months into his new post, Deputy Sheriff William Irwin, serving out of the

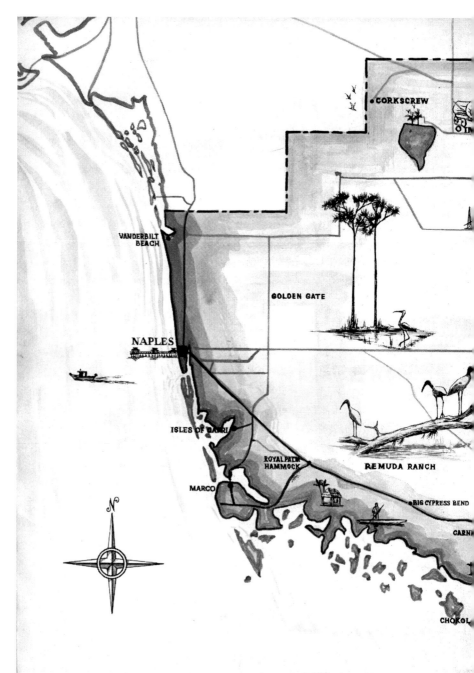

Heritage Trail Map, indicating the way stations along Tamiami Trail, 1973. *Courtesy of Collier County Florida Jubilee Collection.*

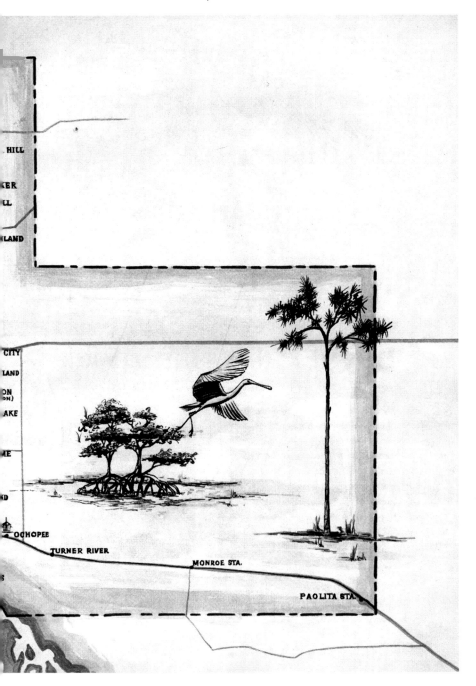

HILL

ER

LL

LAND

CITY

LAND

ON
ON)

AKE

ME

D

OCHOPEE

TURNER RIVER

MONROE STA.

PAOLITA STA.

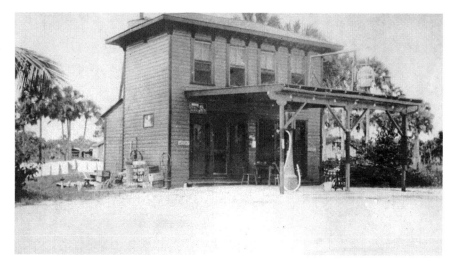

Royal Palm Hammock Way Station, located near the entrance to Collier Seminole State Park along the Tamiami Trail. *Courtesy of Big Cypress National Preserve.*

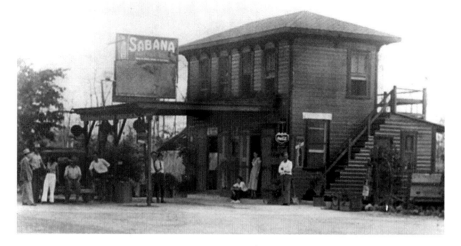

Above: Weaver Way Station, renamed Big Cypress Bend Station and located across from the Fakahatchee Strand Preserve Boardwalk—destroyed by Hurricane Andrew in 1992. *Courtesy of Big Cypress National Preserve.*

Opposite top: Monroe Way Station, located north of the Carnestown–State Road 29 Juncture, now owned by the Big Cypress National Preserve, under future renovation. *Courtesy of Collier County Historical Research Center, Inc.*

Opposite bottom: Paolita Way Station, located along the Tamiami Trail next to the Miami-Dade County line. *Courtesy of Alvin Lederer.*

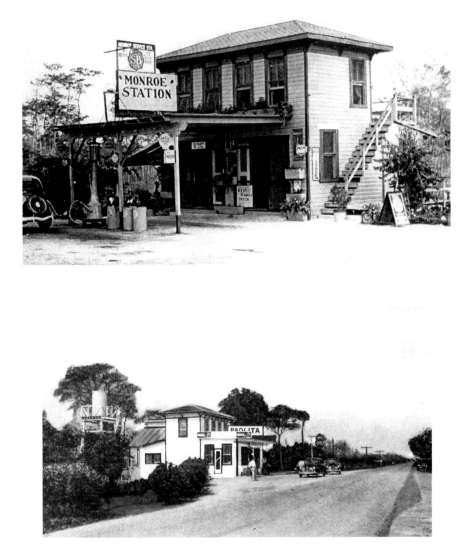

Monroe Station, was killed in January 1929, also while on patrol, after his motorcycle was struck head-on by a motorcar in heavy fog. He is buried in Arlington National Cemetery in Washington, D.C. This job wasn't for everyone; patrolling these long stretches of road in eastern Collier County proved to be lonely and dangerous work.

First Jail (1924)

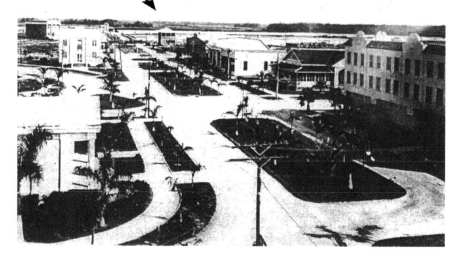

Town of Everglade, 1928. The first jail, indicated by the arrow, was located across the street from the Collier County Courthouse. *Courtesy of Captain Thomas B. Smith, Collier County Sheriff's Office.*

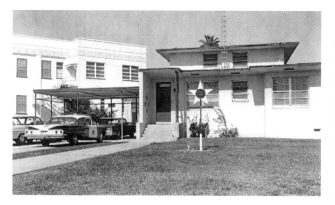

The second jail for the town of Everglade, constructed in 1951, was located next door to the Collier County Courthouse; operated until closing in 1962, when relocated to nearby Naples. *Courtesy of Captain Thomas B. Smith, Collier County Sheriff's Office.*

Collier County's first jail was completed in 1928 and was located in Everglade, across the street from the Collier County Courthouse, which is known today as the city hall. In 1951, a new jail opened, and it was located next door to city hall, where it remained until its closing in 1962. The building remained until its demolition in 1994, and the location remains vacant today. Everglades City was the original county seat for Collier County and remained so until 1962, when it was relocated to nearby Naples, where it remains today on the east side of town.

Since 1923, Collier citizens have had seven sheriffs protecting them, beginning with William Riley "W.R." Maynard, who was appointed in July by the legislature and hand-picked by Barron Collier himself. Maynard was called the "flying sheriff" because he had a pilot's license and was a veteran of World War I. Maynard held the impressive distinction of being the only Spanish-American War veteran to down a German aircraft during the First World War as a member of the Army Flying Corps. Sheriff Maynard was both widely admired and respected in his role. Collier rented an airplane for the sheriff, and Maynard and his assistant compiled the very first aerial photos of Collier County. Maynard was indeed a "force to be reckoned with," according to the locals; he scored ten arrests in his first three months on the job—even without a jail!

At a time when Florida law banned women from jury duty, Maynard appointed his wife, Blanche, as his chief deputy. She, too, was not to be deterred in enforcing the law, and over the years several stories have been bandied about concerning her sheer grit and courage. But the one event that the *St. Louis Post-Dispatch* heralded as an "exploit of extraordinary character for a woman to perform" resulted from her physical efforts and

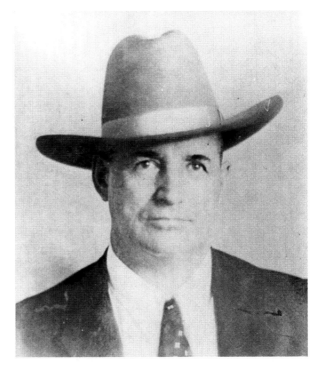

Collier County's first sheriff, William Riley "W.R." Maynard, served from 1923 to 1928. *Courtesy of Captain Thomas B. Smith, Collier County Sheriff's Office.*

determination to track down three escaped prisoners in December 1926, while the sheriff was out patrolling his own beat. Following the jailbreak, it took Mrs. Maynard and her guide thirty hours and fifteen minutes to recapture and march the three prisoners back to their cell. The local press lauded her with an inch-high headline that read, "Everglade has no reason to feel uneasy when the sheriff is out of town. Mrs. Maynard can carry on." Maynard served in this capacity as sheriff for five years before disappearing from public life to manage the family homestead in Sebring, Florida.

Louis J. Thorp was appointed the county's second sheriff following Maynard's resignation in 1928. He was thirty-four and served for twenty-five years until his death while in office in 1953. After Thorp's death, Roy O. Atkins was appointed Collier County's third sheriff. Thorp hired him in 1937 and within four years had appointed Atkins as his chief deputy and senior jailer. Atkins served just two years before Eldridge Albert "Doug" Hendry defeated him to become the fourth sheriff in 1956. Hendry, too, had been hired by Thorp and served until 1975. Hendry was a World War

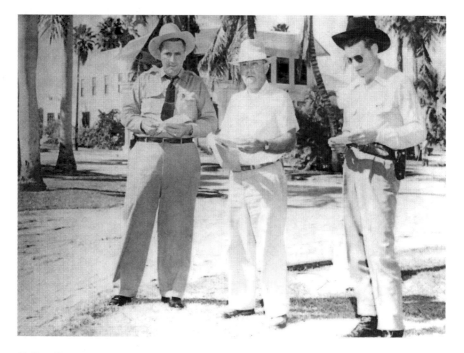

Collier County sheriff Louis J. Thorp, with Deputies Roy O. Atkins and Eldridge Albert "Doug" Hendry, taken in Everglade. *Courtesy of Don Laycock.*

II veteran who had served with General George S. Patton. "Fearless" and "knowledgeable" were adjectives used to describe Hendry. Hendry hired his friend Aubrey Rogers from the Fort Myers Police Department to be his chief deputy. Rogers had joined the police force at twenty-two years of age and was earning a mere $0.74 per hour after serving two years in the U.S. Army. Under Hendry's reign, the sheriff's budget surpassed the $1 million mark in 1971. Sadly, Hendry was stricken with pancreatitis and was near death in 1973. He resigned for health reasons in 1975 but ran again in 1980 against Rogers, who won by a landslide. Hendry, still despondent over his deteriorating health, later shot and killed himself.

Rogers, appointed sheriff in 1976, served for twelve years and was the last sheriff to officially serve in Everglades City, retiring in 1988. He died in March 2010 at eighty-three. Rogers was described as a "plain, simple and uncomplicated man." The Youth Relations Deputy program, still in existence today, was the first program that put deputies into schools and was an offshoot of former Sheriff Hendry's Youth Aid Bureau that he created. Under Rogers's watch, things began changing, not only in Collier County but in law enforcement across the country as well. College-educated deputies were now needed to battle drug smugglers, who were much more sophisticated than the moonshiners back at the birth of our county. Rogers hired the next sheriff in 1979, Don Hunter, a recent graduate from Florida State University who had earned a degree in criminology. Hunter served as sheriff for the next two decades, retiring in 2008. Outgoing Sheriff Hunter had successfully transformed the sheriff's office from a small-town agency to one of the nation's most modern law enforcement agencies. Collier County's seventh sheriff, Kevin Rambosk, came on board following previous roles as Naples police chief, Naples city manager and then Collier County undersheriff.

Everglades City

Carnestown: The Welcome Center

The building with the pointed roof, also known as the Welcome Center of Everglades City, is located at the intersection of Tamiami Trail and State Road 29 in the area known as Carnestown. The center is filled with information for tourists, including maps, books, toys and more, along with pertinent information on the area's various attractions.

Previously, Carnestown, named for one of Barron Collier's sons, was home to both a warehouse, used to house and maintain the equipment, and a work camp for those working on the Tamiami Trail. A road and canal from Port DuPont linked the engineering center to the work station, just off the Tamiami Trail. High water coupled with an inadequate lumber supply rendered the Port DuPont site unsatisfactory, so the mill was moved two miles north to Carnestown, at the crossroads of both Everglade and State Road 29. Lumber produced at the mill in Carnestown was used for bridges in Collier County.

Carnestown today is just a past memory of a once-booming community that played an instrumental part in the building of the Tamiami Trail.

COLLIER COUNTY COURTHOUSE, AKA EVERGLADES CITY HALL

The grand two-story white stucco building right on the town's circle, designed in the Classical Revival style, was opened in 1928 by county namesake Barron Gift Collier as the Collier County Courthouse. It remained in operation here until 1962, when it was moved to nearby Naples following Hurricane Donna's wrath in 1960. When it opened, there were only three full-time county employees at the courthouse: clerk of the circuit court, the sheriff and the superintendent of public instruction. Back in the day, a circuit-riding judge would occasionally arrive by boat to try the pending cases.

Before the courthouse was completed, the county court took turns meeting at the Manhattan Mercantile, the Rod & Gun Club or the bank building. In 1963, after some deliberation, the city government moved into the former courthouse following its recent move up to Naples. During the past decade, many of the rooms were used by local businesses as gift shops or for a realtor, travel agent, bank and others.

Everglades City Hall has seen its share of hurricanes, and Hurricane Donna in 1960 was no exception. There were more than one hundred people who

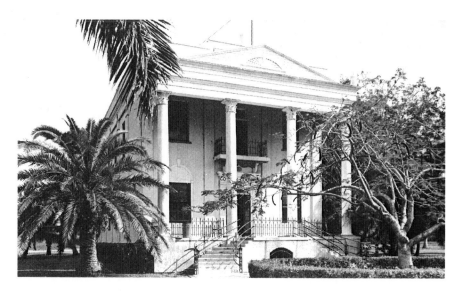

Collier County Courthouse, built in 1928. *Courtesy of Florida State Archives.*

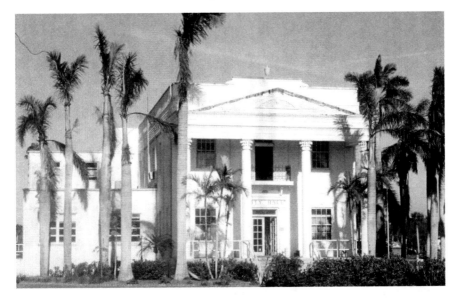

Renovated Everglades City Hall, after Hurricane Wilma, reopened in 2007. *Photo by author.*

sought shelter on the second floor as the waters continued rising over ten feet. Hurricane Wilma, in 2005, only added to the depressed state of the building, and it was deemed uninhabitable and condemned. There would be light at the end of the long tunnel, though, because with the damaging hurricane relief came much-needed Federal Emergency Management Agency (FEMA) funding; the once grand courthouse would now be rescued. Following months of renovation, Everglades City Hall has returned to its former prominence, with special thanks to Mayor Sammy Hamilton's determination, coupled with support from members of the Everglades Society for Historical Preservation, as well as a combination of county, state and federal funds.

The much anticipated reopening ceremony, dubbed "Restoration Celebration," was held on January 27, 2007, with more than three hundred citizens on hand to witness the ribbon-cutting ceremony, followed by a parade, lunch and then tours of the renovated building. Today, in addition to the Council Chambers, mayor's office, city clerk office, building official office, planning and zoning office, Collier County sheriff's office, City of Everglades water billing office and Collier County branch library, the building is also home to the Betterment Association and the Everglades Society for Historical Preservation, as well as the Shamrock Bank. Once again, Everglades City Hall stands tall and proud.

BANK OF EVERGLADES

This isn't just any old bank—it was the first one in Collier County. The Bank of Everglades was built in 1923 by the county's namesake, Barron Gift Collier, when Everglade was the original county seat. The bank remained the only financial establishment until 1962, when its charter was sold and it was moved to nearby Immokalee. One of the bank's treasured exhibits is the original safe, weighing some three thousand pounds.

Over the years since its closing, the bank has seen many changes, including a stint as a boardinghouse; then the former local newspaper, *Everglades Echo*, was established in the bank building. Speaking of the newspaper, the founding publisher, Reba Opel "Rusty" Wells Rupsis, had a most interesting

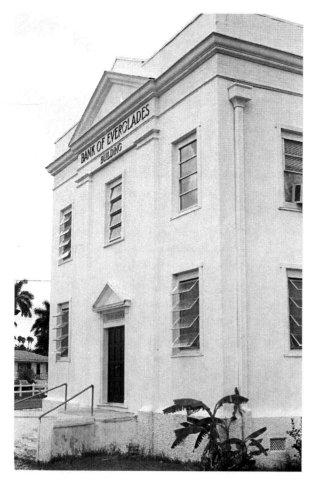

Bank of Everglades façade, 1994. *Photo by author.*

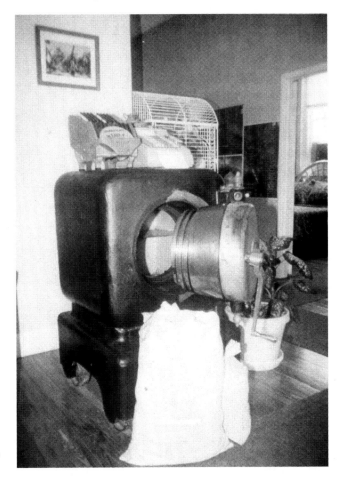

The Bank of Everglades' three-thousand-pound safe, 1994. *Photo by author.*

life. Born in Kentucky in 1914, she later joined the Women's Army Corps in 1943 and volunteered for overseas duty. She was sent to France following the invasion at Normandy and remained there until Germany surrendered. She returned stateside with the rank of sergeant and resumed civilian life, arriving in Florida in 1970. Rusty had intended to manage an Immokalee-based newspaper that was looking to begin a weekly in Everglades City. When the deal fell through, Rusty decided to strike out on her own. So, at sixty-six years old, she founded the *Everglades Echo* weekly newspaper in 1979, with only $700 and a whole lot of determination. In this new role, Rusty served as publisher, photographer, reporter, sales manager, production director, circulation head and delivery person, all rolled into one, for nearly ten years. Rusty was elected and served on the Everglades City Council and

was the top vote getter among the candidates. Rusty engaged then local artist Camille Baumgartner to design the newspaper's flag. Rusty retired in 1989 after selling the newspaper to the Tuff family. She later sold the bank building and moved to Punta Gorda with her husband, where she lived until her death in 2002 at eighty-eight.

The next bank owners, a father-daughter team from Naples, completely revamped the building back in the late 1990s, restoring the pine hardwood floors under layers of carpeting and turning it into a delightful bed-and-breakfast called On the Banks of the Everglades. The B&B's twelve rooms offered guests single rooms, suites and efficiencies that consisted of names

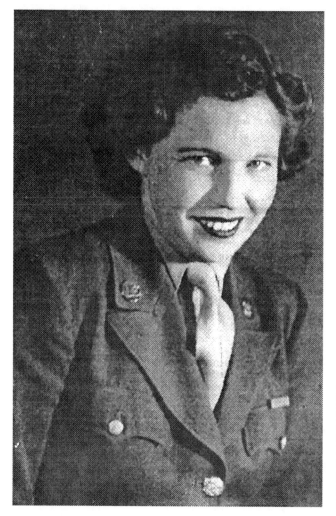

Everglades Echo weekly newspaper founder Reba Opel "Rusty" Rupsis in uniform, circa 1940s; she began publishing the newspaper in the former bank building in 1979. *Courtesy of the* Everglades Echo.

The *Everglades Echo* flag, illustrated by then local resident and artist Camille Baumgartner. *Courtesy of the* Everglades Echo.

like the Trust Department, the Checking Department, the Loan Department and more. Another delightful surprise to guests at the B&B was breakfast held in the bank's actual vault, which once held money and mortgage notes.

The bank's most colorful story followed the flooding by Hurricane Donna in 1960. With five feet of water inside the building soaking all of the money in the bank, the employees had to literally hang the bills on an outside clothesline in order for the paper money to dry. They also had to keep watch over it all night, and the following morning, too, and not one bill was missing when it was all added up. A remarkable feat, at least by today's standards, was that in its thirty-seven years as a bank it was never robbed—probably because there is only one way in and out of town, which would make for a difficult escape.

Unfortunately, the B&B, with its charming yet remote location, made this endeavor yet another chapter in its colorful history. After the B&B was closed, it reopened as a day spa, but that didn't last long either. Sadly, today the old building is currently on the sale block, although the local Everglades Society for Historic Preservation is working to save it from the wrecking ball. The bank was added to the prestigious National Register of Historic Places in 1974.

COLLIER'S TOWN LAUNDRY BUILDING BLOSSOMS INTO MUSEUM OF THE EVERGLADES

What began as a commercial laundry facility for developer Barron Gift Collier's planned settlement in the town of Everglade in 1927 has, in the ensuing eighty-three years, served as a barbershop, a thrift store, a restaurant,

an insurance company and even a church before becoming home to the local Woman's Club. The tiny single-story building located on West Broadway in Everglades City, south of the Tamiami Trail, has indeed stood the test of time, despite flooding, hurricanes and storms.

The building, now known as the Museum of the Everglades, was given to Collier County in 1992 by members of the Everglades Woman's Club with the stipulation that it be used as a museum to house the area's memorabilia and at the same time offer visitors a look at the early days and events that shaped both Everglades City and Collier County. This museum also serves as the first satellite museum of Collier County.

It was here where the uniforms of the workmen from the Collier Corporation were washed, as were the linens from both the nearby Rod & Gun Club and the Everglades Inn. Collier himself had his own personal laundry washed here and would even send it by the mail boat when he was staying in Useppa. Both the Ayers and Echols families leased the laundry from the Collier Corporation. The laundry closed during World War II due to a lack of workers.

During the renovation process, 70 percent of the lumber from the original structure was actually restored. It would take ten years, numerous fundraisers

Former Everglade Town Laundry. During the renovation process, 70 percent of the lumber from the original structure was actually restored, circa 1990s. *Photo by author.*

and a steady stream of volunteers, according to the late first president of the Friends of the Museum, Pauline Reeves. She had nothing but high praise for the "stellar group of volunteers" with whom she worked during the past decade. "Everglades City was the county seat, and so much of Collier's history began right here, and we feel it should be told right here," she added. Another coup for the building was its addition to the U.S. National Register of Historic Places in September 2001.

The museum's renovation, buried under nine layers of paint during the first seventy years, proves the community's determination to keep its local history alive for generations to come. Visitors inside the museum will find several antique laundry and dry cleaning machines on display in keeping with the

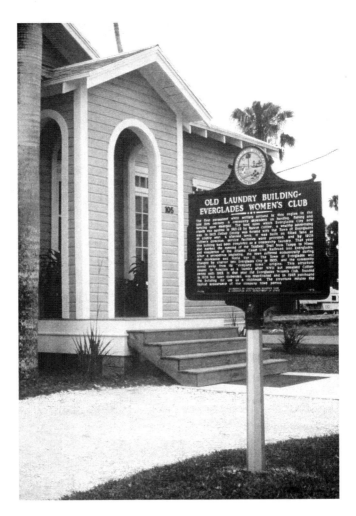

The Museum of
the Everglades
officially opened
on April 26, 1998.
Photo by author.

original function of the building. Since its opening in April 1998, custom-made wood and Plexiglas cases, replicating the late 1920s style, have been installed to house artifacts, models, miniature dioramas and other historical photographs. Enlarged photos depict the Seminoles, the completion of the Tamiami Trail, local pioneer families and Deaconess Harriet Bedell, who ministered to the local Indians. All of this and more await the visitor to the former laundry building in Everglades City.

Speaking of historical buildings, the museum is surrounded by several other old buildings, remnants from the original town of Everglade that include the Bank of Everglades building, the Rod & Gun Club and Everglades City Hall (the former Collier County Courthouse), as well as the former Atlantic Coast Line Railroad, now referred to as the Everglades Seafood Depot. These historic relics serve as sentinels of the past, depicting the area commonly known as the Last Frontier.

ATLANTIC COAST LINE RAILROAD DEPOT

The Spanish-style stucco building, home of the Atlantic Coast Line (ACL) Railroad Depot, typical of the 1920s Florida railroad architecture, still welcomes visitors to Everglades City as it stands on the left as you make the right turn into the heart and circle of the city; it has since its opening in June 1928 been just one more important component of Barron Gift Collier's company town. The stationmaster had living quarters on the second floor, and rail workers' cottages dotted the strip of land between Collier Avenue and Lake Placid.

"Construction of the railroad was parallel to the building of State Road 29 from Everglade to Immokalee, from where the rail continued north to Haines City. Before the ACL track was laid, a primitive railroad dating from 1913 had run from the Deep Lake grapefruit grove to Port DuPont," according to the Friends of the Museum of the Everglades' *Historic Buildings around Everglades City Walking Tours* book.

Carrying both passengers and freight, the trains enabled local farmers to ship their goods much quicker and at much farther distances. In addition to people and freight, the trains also delivered mail. "A combination baggage-coach car ran from Everglade, dubbed the southernmost point on the Coast Line system, to Immokalee. Thirty-two people could be accommodated, but it lacked air conditioning," according to railroad historian and author Gregg M. Turner.

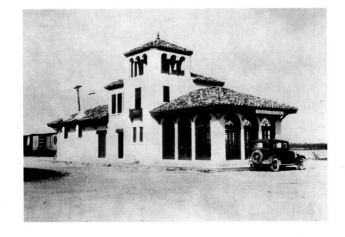

The Atlantic Coast Line Railroad Depot opened in June 1928 and served the area until 1956. The railroad tracks were removed in 1959. *Courtesy of Florida State Archives.*

A mixed train appeared on a triweekly basis until its closure in 1956. The old railroad tracks that formerly brought people and goods to this small outback area were removed in 1959, but some of Everglades City's more famous visitors were filmed at the depot during the production of Budd Schulberg's *Wind Across the Everglades* back in 1957.

After more than thirty years of service to Everglades City, the ACL gave up rail service and the depot fell into private hands. Since the last whistle blew in the mid-1950s, the old depot has been used as a restaurant.

While the old historical depot may not be the major community hub it once was, as Collier had initially planned, it still serves the local community as a restaurant and meeting place now known as the Everglades Seafood Depot Restaurant.

THE EVERGLADES INN: SIXTY-THREE YEARS OF MEMORIES

In less than an hour, the historic Everglades Inn building was reduced to a pile of rubble, following the early morning blaze on May 11, 1987. Only the chimney and an exterior steel stairwell remained. This Collier-planned building, located in the "business district" for his company town, was located on the corners of Broadway and Allen Avenue. Touted as the "social hub" of the town, it was built in 1924. This three-story building (the third floor was added in 1928) offered forty-five rental rooms and apartments on the upper floors. The ground floor housed a barbershop; the Manhattan

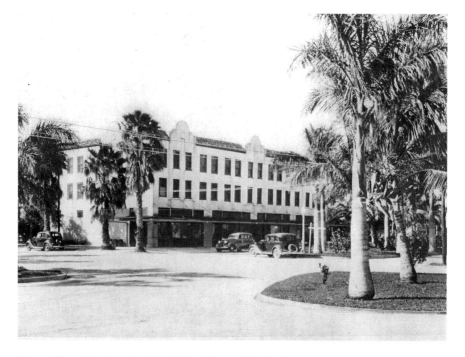

Former Everglades Inn, built in 1924 and located in the "business district" of town, was reduced to rubble following a fire in 1987. *Courtesy of Florida State Archives.*

Mercantile (department store and another Collier enterprise); a drugstore that later became Mama Dot's Malt Shop in 1968 (with the best burgers around); a hardware store (Win-Car Hardware & Dry Goods); a medical clinic; and sundries (Everglades Sundries Store). It also was home to a lounge and dining room managed by the German chef Claus "Snooky" Senghass, whom Collier had discovered during one of his trips abroad. (Snooky would later oversee the Rod & Gun Club dining room.)

The tragic fire not only left residents and employees without businesses and jobs but several residents without homes as well, since many workers lived on the second floor. Fortunately, no one was injured or killed in the fire. The only business that survived and moved on was the hardware store, which is still thriving. Win-Car Hardware was relocated to Collier Avenue and remains a treasure-trove of goodies, ranging from Florida books by local authors to fishing, camping, hunting gear and equipment, as well as the regular items found in most hardware stores: paint, brushes, flashlights, batteries, hammers, nails and much more.

Local firefighters from Everglades City as well as Ochopee were joined by their fellow firemen from nearby East Naples, Isle of Capri, Immokalee and even Corkscrew; unfortunately, the type of wood used in the construction was pine, according to then Ochopee fire chief Vince Doerr. Pine is a strong wood for building but a quick-burning wood when set alight.

All that remain now are memories from the sixty-three years it served the local community.

THE IVEY HOUSE: FROM RECREATION HALL TO BED-AND-BREAKFAST

While construction of the Tamiami Trail was underway, Barron Gift Collier built a recreation hall for the workers. It was erected at Port DuPont on the Barron River, and the building housed both a pool hall and a bowling alley. Following the 1925 hurricane, the building was moved to its present-day location at 107 Camellia Street.

One of the men working on the Tamiami Trail for Collier was Earl W. Ivey. He was responsible for one of the Bay City Walking Dredges used to create the road bed. He specifically worked on the ten-mile stretch

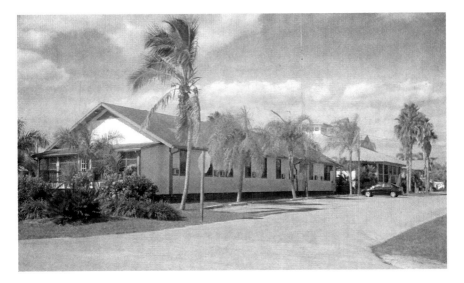

Former Recreation Hall, for workers on the Tamiami Trail—known today as the Ivey House, a bed-and-breakfast, 2005. *Photo by Marya Repko, ECity-Publishing.*

between Black Water River and the Belle Meade Crossing from 1927 to 1928. Once the road was completed and opened in 1928, Collier interests converted the hall into a boardinghouse; Ivey and his wife, Agnes, ran the house for the Colliers until 1960, when the Iveys purchased the house themselves. Sadly, Ivey passed two years later, but his wife continued running it until she passed in 1974. For the next three years, the hall deteriorated, until Beckett Academy acquired the building to be used as a dormitory and classroom for troubled youths, as part of a wilderness experience school.

The David Harraden family, owners of the North American Canoe Tours, Inc., initiated overnight guided canoe adventures in the Everglades National Park backcountry in 1979. Ten years later, the Harradens purchased the Ivey House from the Beckett Academy and renovated it into a bed-and-breakfast.

Today, the Ivey House retains the typical appearance of the former company town era.

EVERGLADES COMMUNITY CHURCH: THE FRIENDLY LITTLE CHURCH ON THE CIRCLE

Way back in 1888, the Florida Conference of the Methodist Church sent the Reverend George W. Gatewood to Everglade on a scouting mission for the purpose of "surveying the field" for the benefit of establishing a church. They in turn dispatched the Reverend H.S. Miller to the field to organize and manage the early church, which was erected at Halfway Creek for one year. Reverend Gatewood later returned as resident pastor, living with Captain G.W. Storter until he married in 1892.

Receiving little money for their services, the Gatewoods never lacked for anything, due to the plentiful game, fish, fruits and vegetables around. Pastor Gatewood remained on the circuit for four years while making friends with the Indians. The Conference decided not to renew Gatewood's position, and there followed itinerant preachers of various denominations up until 1913, when a Baptist minister, G.F. Giles, arrived in town with the goal of reorganizing the Sunday school, which had ceased operations.

Everything went well, until the church was destroyed and the religious services were moved to the schoolhouse in Everglade, until it was blown away. Another church was built, and the church was also used as the school until it, too, was destroyed.

Just prior to Barron Gift Collier's arrival in the early 1920s, the church membership was waning. A new pastor, Reverend Gerrett Koyker from Iowa, was secured for the now Presbyterian Church, and he began in October 1925 with weekly Sunday services. The Everglades Presbyterian Church was official in February 1926. A new pastor arrived later: the Reverend Janles L. Glenn. The congregation held services in the Community House until construction of the present church was completed in 1940—with the exception of the hurricane floods in 1926 and the fire of 1927. Reverend Glenn also served as a pastor for the mission on Chokoloskee, as well as in Marco and Naples. Reverend Glenn also held services for the local black community until they organized their own church in 1927 at Port DuPont.

Then, in 1939, the Collier Corporation offered land for the new church, providing it be opened and henceforth remain a nondenominational

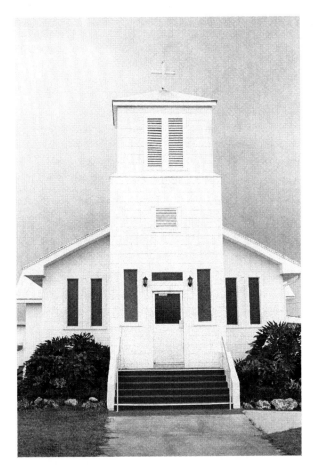

Everglades Community Church, the friendly little church on the circle, 1994. Photo by author.

church; it also had to be completed by October 1940. Failure in any of these stipulations and the church and whatever improvements had been made would revert back to the Lee County Land Company. Construction began in the fall of 1939 and was completed in April 1940.

On March 14, 1951, Everglades Community Church officially renounced jurisdiction of the Presbyterian church. The resolution went on to add that "the Everglades Community Church…recognizes no denominational body as having authority over said church" and "recognizes the congregation of Everglades Community Church as the only source from which it will receive orders or directives."

A new chapter evolved for the congregation in March 2006, when the Reverend Dr. Bob N. Wallace became the pastor. On September 4, 2007, Everglades Community Church was proclaimed to be historically preserved, having surpassed eighty years of services. The church underwent a complete renovation while celebrating its eighty-fourth birthday in 2010. It remains today as the friendly little church on the circle in Everglades City.

Everglades City Schools, K-12

Teachers have been teaching the local students in Everglades City and its surrounding areas ever since 1893. Everglades City School has the rare distinction of being one of just two K-12 schools in the state of Florida. In addition to those students living within Everglades City, others attending come from the surrounding areas that include Ochopee, Jerome, Lee-Cypress and Copeland, as well as Plantation and Chokoloskee. Before the causeway was completed in 1956, students from Chokoloskee came by boat.

J.W. Todd, from Tennessee, began giving lessons to a half-dozen students from one room in the George W. Storter residence, now the Rod & Gun Club. The first school was constructed in 1895 and was washed away in a cyclone. It was rebuilt on the same site; however, it was also lost and was last seen floating upriver following the 1910 hurricane. An article posted in the *Naples Daily News* in March 1983 read, "What had begun as a one-room school has now grown into a two-room school with two teachers and 45 pupils by the fall of 1923." This same article went on to note that PE (physical education, now called gym) was composed mostly of swimming. Two of the older boys watched for alligators, while the others dived into the river. The fourth school was built and expanded with the high school

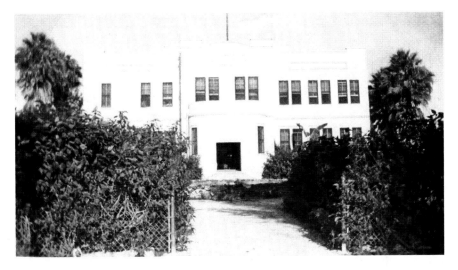

Former Everglade School, circa 1940s. *Courtesy of Chris Hancock.*

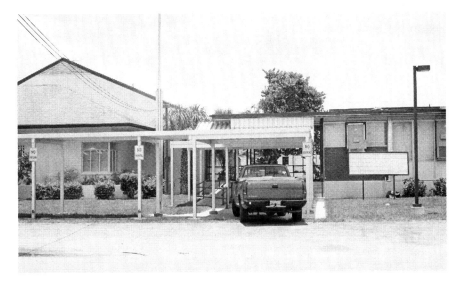

The Everglades City School was built in 1961 and served until the current school opened in 1995. Image taken in 1994. *Photo by author.*

opening in 1926. This school stands on the current site of the Everglades City School. It was torn down in 1961. The Everglades Parent Teacher Association was established in 1931. The entire student body was housed in a former high school building at one time, roughly from 1923 until 1948. In

1960, the high school was built and would remain in use for the next thirty years until the current school opened in 1995.

One of the more colorful teachers in Everglades City, and certainly the one with the longest tenure, was Ruth Neal. Miss Neal arrived in the summer of 1926 to visit her father, Otto Neal, who was in charge of the construction of the Tamiami Trail. The young college graduate from Indiana began teaching both science and mathematics and was on the school staff when the first students graduated in 1928. She also coached girls' sports. She retired in 1973, never missing a day in her forty-five-year career. She passed in 1996 at ninety-two.

Black students began their first-through-eighth-grade classes in a one-room church in Port DuPont in 1924. Four years later, the classes had moved into a boardinghouse previously used by those men working on the Tamiami Trail. DuPont School was built in 1957 for the elementary students, while the high school students were bused to Bethune High in nearby Immokalee. Integration began in 1966, and within two years total integration was completed.

THE ROD & GUN CLUB'S COLORFUL HISTORY

From Weeks to Allen, Storter and Collier—all of these pioneers played an important role in the establishment of today's Everglades City. Weeks originally farmed along Potato Creek, today known as the Barron River. Allen took over Weeks's holdings in 1870. It was Allen who began the initial construction that later developed into today's Rod & Gun Club. Upon Allen's retirement in 1889, he sold the property to George Storter Jr. for $800. Following Allen's death, George W. Storter Jr. would officially take over as Allen's successor. By now, Storter was taking in visiting sportsmen, and he began adding onto the homestead to accommodate hunters and fishermen coming through the area. George Storter Sr. raised sugar cane on Half-Way Creek, while George Jr. took over the house. Brother R.B. "Bembery" built his own home downriver. Soon, Storter Jr. opened a general store, much like his counterpart, Ted Smallwood, on Chokoloskee Island. Storter next opened a post office in 1893, bearing the name "Everglade." At one time, the Storters owned all of the land here in today's Everglades City.

The homestead passed hands yet again in 1922 when New York entrepreneur Barron Gift Collier discovered the region and fell in love

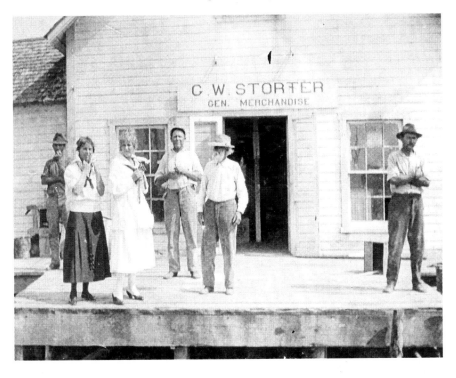

Above: Storter's General Store along the Allen River, circa 1917. Standing in front of the store are Nell and Dot Storter, George Jr., Chokoloskee's C.G. McKinney and Robert Bembery. *Courtesy of Florida State Archives.*

Right: Exterior shot of the Rod & Gun Club in Everglades City, 1967. *Courtesy of Florida State Archives.*

instantly. He purchased the lodge in 1922 and used it as his private club for visiting dignitaries and guests. With Collier's "master plan" for his company town shaping up, he was excited about the future. Once the sale was completed, the home was renamed the Rod & Gun Club.

On a European visit, Collier was impressed with a young Bavarian maitre d' named "Snooky" Senghass and convinced him to come to Everglade. "Snooky" contributed much to the budding new town, and soon his delectable creations were the talk of the town. "Snooky" began his ventures at the nearby Everglade Inn, until the Rod & Gun Club opened in 1925. And he could certainly "shine" in the kitchen. He was the consummate host, taking the time to make sure that everyone was having a good time. He passed in 1954.

Over the years, the club has hosted numerous celebrities and four U.S. presidents, including Theodore Roosevelt, Harry S. Truman, Dwight D. Eisenhower and Richard Nixon. The club has also been used as the backdrop of several movies that have been filmed here on location.

After the Collier Corporation moved to Naples in 1962 following Hurricane Donna, the club was sold to the Alliance Machine Company. Later, in 1973, the Bowen family purchased the club, and they maintain ownership today. The interior still has its "pecky cypress" walls and Dade

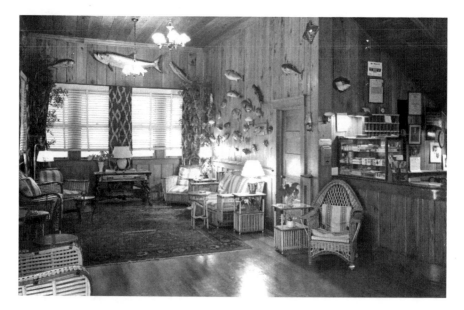

Interior lobby shot of the Rod & Gun Club, late 1950s. *Courtesy of Alvin Lederer.*

County pine floors. One of the most enjoyable things I find about the Rod & Gun Club is poring over all of the history posted on the walls in the narrow hallway leading into the lobby. The old black-and-white photographs are just the perfect time capsule of life here in the Last Frontier.

EVERGLADE PIONEER

David Graham Copeland: The Driving Force Behind the Last Frontier

Born in 1885 in Bamburg, South Carolina, David Graham Copeland received his education at the U.S. Naval Academy in Annapolis, Maryland, and then served at the Philadelphia Navy Yard. Copeland was handpicked

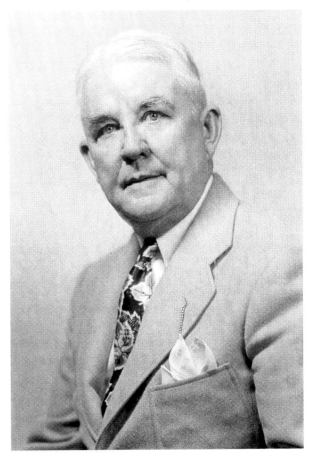

David Graham Copeland, driving force behind the Last Frontier, State Representative photograph, 1949. *Courtesy of Florida State Archives.*

by Barron Gift Collier to supervise the planning and building of his company town, out of the vast wilderness, which served as the base, while simultaneously directing the building of the Tamiami Trail against amazing odds. Copeland, a brilliant civil engineer, rose to that challenge and indeed transformed this area into the new county seat, having worked on other large-scale assignments with military precision.

Within a few years, the new town boasted a courthouse, a school, a bank, streets, a repair shop, a railroad, a weekly newspaper, the *Collier County News*, electricity and stores, as well as regular mail service. During his twenty-three-year career with Collier, Copeland managed roughly forty companies, including hotels, retail stores, a steamship line, the Bank of Everglades, a local school and others. Copeland was extremely instrumental in bringing the Atlantic Coast Line Railway to southwest Florida. He also served on the Everglades National Park commission. And Copeland was chairman of the Collier County Board of Commissioners from 1929 to 1947, and from 1947 until 1949 he served as a state representative, supporting conservation issues.

A southern gentlemen to the end, Copeland died in 1949.

David Graham Copeland's Great Floridian plaque is located at the Museum of the Everglades, 105 West Broadway, Everglades City.

COLORFUL CHARACTER

Harriet Bedell, Deaconess of the Everglades

No story on the history of the Everglades would be complete without including Deaconess Harriet Bedell, who lived and worked among the Seminole Indians of southwest Florida for almost thirty years, beginning in 1933. Upon hearing of the great need for missions teachers in China, in 1904 twenty-nine-year-old Bedell questioned the visiting pastor, who was himself on furlough from China, about what steps would need to be taken to become a mission teacher. His response would change her life dramatically.

Coming from a close-knit family, Bedell lived with her widowed mother and younger sister and brother. Her father had tragically drowned after falling overboard from a boat when she was only ten years old, and her mother raised the three children by herself. Bedell's future, though possibly

humdrum, was secure as a teacher, and she also held the position of assistant principal.

Bedell reasoned that in Buffalo, New York, teachers were plentiful but that in China it was an entirely different story. As a student, Bedell learned to wear many hats. In addition to teaching, she also learned to cook and care for the sick. She learned bookkeeping as well as nursing. After filing the necessary papers to begin her schooling, Bedell waited. While she was never able to persuade her mother to let her go to far-off China, her mother did finally relent and permit her to attend the necessary deaconess classes in New York City, thinking that this would squelch her desire to go abroad.

At the New York Training School for Deaconesses, Bedell learned the basics, in addition to her study and training requirements—basic things that would often be required of those mission teachers located in remote regions with no real doctor to be found within miles. Additionally, she would also be required to take a training course in hospital nursing; because of her family's contacts, she was given permission to train at General Hospital in Buffalo, her hometown. Upon completion of her training, Bedell was given her assignment and relocated far away from her family.

Her first mission assignment led her to work on a remote Indian mission in northwest Oklahoma, working with the Cheyennes. The nearest town was forty miles from the mission, and she would be the only white woman for miles in any direction. Bedell was no stranger to Indians. She had spent some time working with Indian children, having taught Sunday school for four years to the Seneca Indians on the Cattaraugus reservation just south of Buffalo. Bedell spent the next nine years here, having sporadic thoughts of going to China some day. Bedell was well respected and trusted by the entire tribe.

Because of her extensive knowledge of the Indian life, coupled with her teaching background, she was asked to take on an assignment in the outer reaches of Nenana, Alaska, where she braved subzero temperatures and long, severe winters. Feeling something missing, she asked for and was granted a transfer to a small town only forty miles from the Arctic Circle, called Stevens Village. Another remote region, Bedell once again was the only white woman for miles in any direction. Later, her mission was transferred to Tanana and to an abandoned mission hospital after the government-built hospital was opened. Here in Alaska Bedell spent two decades of her life; while still working in Alaska, Bedell was finally ordained a deaconess in Portland, Oregon, in 1922.

The fifty-seven-year-old Bedell was invited to speak about the Alaskan field on behalf of the Chain of Missions in Miami, Florida, in 1933 while procuring funds for an Alaskan mission. After touring a nearby Seminole reservation in the Everglades, she found her calling. She was appalled by the living conditions among the Miccosukee and Seminole Indians and began her campaign to improve their quality of life, helping them to become more self-reliant while reviving their doll-making and basket-weaving skills, which had nearly become extinct. Bedell never returned to Alaska.

Bedell rented a company house from the Collier Company right in Everglade for the sum of $20 per month. She learned to drive an automobile in a week's time after purchasing a second-hand Model A sedan Ford for $298. A car was essential, as her many charges lived miles apart from one another all along the Tamiami Trail. Bedell soon established her mission, Glades Cross Mission, in today's Everglades City. In addition to leading the local Indians to Christianity, Bedell was also responsible for the teaching and healing. Few Indians could read or write English, and their children were not sent to white schools. Bedell knew that working with these Indians would be a tremendous task, nearly impossible. Deaconess Bedell also held Sunday school services for the white people from Immokalee, Everglade, Goodland and Marco Island. Bedell shared that one of the hardest parts of her duties was completing her parish rounds while "poling" a dugout canoe through the swamps to reach those isolated Seminoles. Picture now a tiny bespectacled woman in a long flowing habit and boots, a woman of God, no less, standing in a low dugout canoe and using a long pole to navigate her way through the swamps. Bedell seemed to have had no fears of alligators, bears, panthers, snakes or other wild animals in this desolated wilderness—or even of the swamp itself.

These Indians were a reserved bunch and had nothing to do with "whites." Undaunted, Bedell continued her efforts and little by little gained their trust, which took three years of painstaking dedication and devotion. Bedell went to David Graham Copeland, the general manager of the Collier Company in Everglade, to work out a business arrangement. She would "pay" the Indians for their handiwork in tickets that could be redeemed at the Mercantile for food or other supplies. Their assorted goods would be put on display at the Glades Cross Mission. Items included bead necklaces and bracelets, dolls, toys made from coconut fiber, baskets and clothing. In essence, the deaconess acted as a nonprofit agent for the Seminoles.

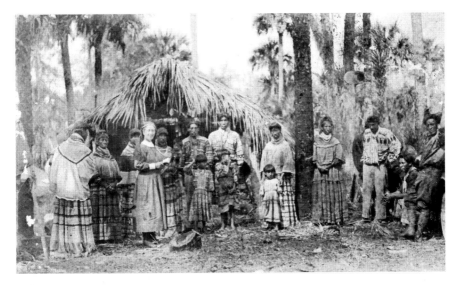

Deaconess Harriet Bedell, with local Indians, after her arrival in 1933. *Courtesy of Chris Hancock.*

Even though Bedell had been obliged to retire at the age of sixty-eight in 1943, she would succinctly remind those that "there is no retirement in the service of the Master." Realizing that her work still needed to be done, Bedell was instrumental in the Indians' gaining tribal status and acquiring some 200,000 acres of the Everglades where they could have their own school. And she also made sure that they were not displaced when the Everglades National Park was opened in 1947. Speaking of the park's opening, Deaconess Bedell was invited to offer the invocation at the park's dedication and later ate lunch with President Harry S. Truman at the Rod & Gun Club. Marco Island historian Marion Nicolay has a fond kinship with the late deaconess as a character actor. She was quoted in the *Marco Island Eagle* newspaper in July 2009 as saying that Bedell had "an acid wit." She went on to share that after dining with President Truman following the park's dedication, she was asked what it was like to sit with him; Bedell quipped, "He was all right for a Baptist."

When Hurricane Donna blew into Everglades City in September 1960, it was still the county seat. The destruction of her church, as well as her personal belongings, forced Bedell into nearby Naples, where she stayed for a few weeks. The Episcopalian rector of Naples, Father Lambert, later took Bedell to the Bishop Gray Inn, an Episcopalian retirement home in

Davenport, Florida. She never returned to Everglades City, except that first December for her annual Christmas party that she gave to the Indians. Three months after Donna's powerful punch and prior to the Christmas party, Bedell stopped back to look at the remains of her home and declared, "Apparently, I've lost my physical possessions. But I'm certain of one thing. Not even a disaster like this one can ever take away a person's spiritual belongings." Bedell remained in Davenport, "taking charge" of the locals until her death on January 8, 1969, at age ninety-four.

The Museum of the Everglades has erected a plaque in Deaconess Bedell's honor. Her Great Floridian plaque is housed at the museum located at 105 West Broadway, Everglades City, Florida.

Additionally, Deaconess Bedell was added to the "List of Lesser Feasts and Fasts" at the national convention of the Episcopal Church of America in Los Angeles in the summer of 2009. Her feast day is January 8, the anniversary of her death.

PART II

SPECIAL EVENTS

ANNUAL SEAFOOD FESTIVAL

In 1973, the local residents gathered together to raise money to build the children a public park.

Locals, expecting to feed roughly five hundred people during that initial festival, created the very first Everglades City traffic jam when more than five thousand people arrived. Those humble beginnings of that first "little fish fry" have now become an annual event that has attracted close to two million people during its past thirty-seven years. Recognizing the fundraising potential of this festival, the citizens decided to host it annually, and both the festival and the Everglades Betterment Association, a nonprofit agency that oversees the funds from these festivals, were born.

The festival is held the first full weekend in February, beginning on Friday, billed as Family Night, and running through Sunday evening. Entertainers differ from year to year, from relative newcomers to country and western giants like the Grand Ole Opry's Little Jimmy Dickens; the one thing that hasn't changed, though, is that the proceeds from this festival remain in the community. In addition to building that initial park, proceeds have also purchased various necessary equipment for the fire station, as well as for the volunteer firemen themselves. They have built a community center, provided playground equipment, provided equipment to the emergency medical departments, renovated the children's skating rink, provided scholarship money for the local students and much more. The local high school juniors and seniors man the soft drink booths, with the

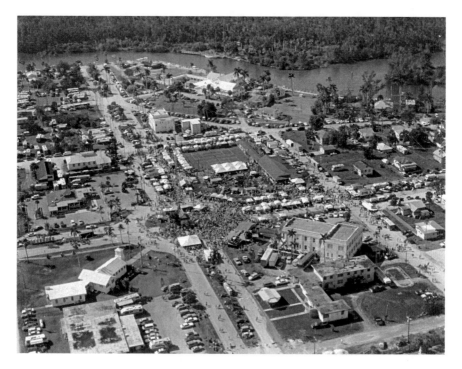

Like ants at a picnic—aerial view of the 1994 Annual Seafood Festival. *Photo by author.*

proceeds assisting with prom expenses, as well as yearbooks. Some of the funds are also set aside for the annual Grad Bash in Orlando. Due to the small class sizes (even some as few as six), some of the funds are distributed to the freshman and sophomore classes for their future graduating expenses.

In addition to the seafood, there are other items that visitors can purchase, such as hamburgers, barbecue, popcorn, funnel cakes, cotton candy, ice cream and more. There are numerous crafters and vendors of all sorts, both local and some from throughout the United States, displaying their homemade crafts and wares, running the gamut from books to spices and more. Many of the area's civic groups and churches host booths for fundraising projects as well. And there are also carnival rides for the kids, as well as alligator wrestling.

Be sure to try the fish chowder, fried mullet, stone crab claws and shrimp, coupled with the usual sides of coleslaw, hush puppies, corn on the cob and even smoked mullet. Additionally, several American Indians are on hand to serve up their traditional Indian fry bread and Indian burgers. And if you've never tried frog legs or alligator, which reportedly tastes like chicken, this is your lucky day!

EVERGLADES NATIONAL PARK DEDICATION, 1947

"Here are no lofty peaks seeking the sky, no mighty glaciers or rushing streams wearing away the uplifted hand. Here is land, tranquil in its quiet beauty, serving not as the source of water but as the last receiver of it. To its natural abundance we owe the spectacular plant and animal life that distinguishes this place from all others in our country," proclaimed President Harry S. Truman during his dedication and opening address of the 1.3 million acres comprising the Everglades National Park on December 6, 1947; amid a nationwide radio hookup, thousands of citizens were in attendance, as well as the press from around the nation. Even back then, many knew that this park was different; it was established as a park in order to protect its very delicate environment and not because of its spectacular scenery. The dedication ceremonies for the park took place at the airfield.

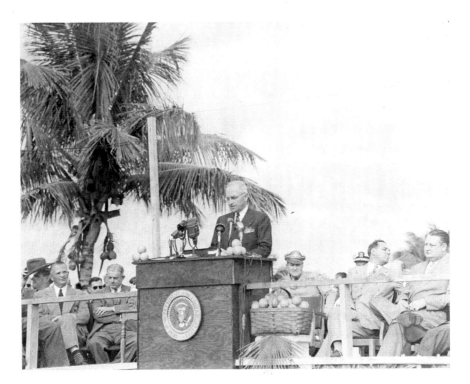

President Harry S. Truman dedicating the Everglades National Park on December 6, 1947. *Courtesy of Florida State Archives.*

Prior to President Truman's remarks, those in attendance had the privilege of listening to the Fort Myers High School band that had traveled to Everglade for this special event. They opened the ceremony with Florida's state song, "Swanee River," composed by Stephen Foster.

On hand with President Truman that historic day were both Marjory Stoneman Douglas and Ernest Coe, commonly referred to as the "Mother" and "Father" of the Everglades. It was their foresight and steadfast determination that helped with the establishment of the park. It was Coe himself, a landscape architect, who wrote the proposal for a national park to be located within the Everglades of southern Florida in 1928. Coe and Douglas both campaigned for decades to have this area protected and created into a park.

Douglas arrived in Miami, Florida, in 1915 to work with her father, Frank Bryant Stoneman, who was the publisher of the *Miami News Record*, which later evolved into today's *Miami Herald*. After five years of research, Douglas's bestselling book *The Everglades: River of Grass* debuted in late 1947; within one month, all 7,500 copies were sold. The timing of her book was perfect, because one month later President Truman dedicated the park. It was while she was researching this book that she came to understand the intricacies of the Everglades; she could see that disrupting any part of this natural "flow" would damage the entire system. This book completely transformed the way the world perceived southern Florida.

Coe arrived in Miami, Florida, in 1925 and immediately fell in love with the Everglades. The more time he spent in it, the more saddened he was and fearful for the animals facing extinction in this region; he decided then and there that Florida would need to save its unparalleled tropical beauty. Coe became an advocate for the Everglades, giving talks and telling every one he saw that this land needed to be protected. Coe dedicated his life and finances toward saving the unique ecosystem of the Everglades as a national park.

Also on hand that day was Deaconess Harriet Bedell, who was invited to give the invocation. In addition to these three above-mentioned guests was a young wildlife technician named Daniel S. Beard, who wrote one of the first comprehensive studies of the proposed Everglades National Park—telling us that it would need *much* protection in order to survive. Beard held the distinction and honor of being appointed the very first park superintendent.

But even before the Florida legislature appropriated the necessary $2 million to purchase privately owned lands within the designated area and other requirements, both the Depression and World War II intervened

and took precedence. Congress authorized the creation of the Everglades National Park in 1934, and more than two million acres were acquired through both public and private donations. That took another thirteen years.

Today, some sixty-three years later, we still haven't quite mastered all of the numerous challenges required in order to restore this park's endangered ecosystem. The late environmentalist Douglas had it right back in 1947 when she declared, "There are no other Everglades in the world," as stated in the opening lines of her book.

HOLLYWOOD COMES TO THE LAST FRONTIER

Even a town as small as Everglades City, with its 513 full-time residents (according to the 2004 census), and the surrounding area have been subjected to Hollywood's charms over the past fifty years.

The first movie filmed on location in Technicolor was Budd Schulberg's *Wind Across the Everglades* in 1958. The all-star cast included a young Christopher Plummer, before *The Sound of Music*; Gypsy Rose Lee; Burl Ives; Peter Falk, pre-*Columbo* and raincoat in his very first movie; and even Emmett Kelly Jr. (Emmett the Clown) with a bit part as an extra named "One Note" by local Chokoloskee native Loren "Totch" Brown. The Schulberg brothers wanted a genuine Gladesman who could not only sing and play the guitar but who could also pen a song about the plume hunters.

Set in the late nineteenth century, the film was based on the arrival of game warden Plummer to Florida (Miami) and his plans to enforce the conservation laws surrounding the poaching and near decimation of the wading birds from the protected rookeries for their plumage used in ladies' hats. Florida would outlaw plume hunting in 1901. In addition to the Everglades National Park scenes, there are also interior shots of the Smallwood Trading Post in nearby Chokoloskee, as well as interior shots of the Rod & Gun Club in Everglades City and exterior shots of the old Atlantic Coast Line Railroad Depot.

In 1995, the exterior of the previous Everglades City School was used in filming *Just Cause*, with leading Hollywood stars Sean Connery, Laurence Fishburne, Blair Underwood and a young Scarlett Johansson. The film, based on the novel by John Katzenbach, is a legal thriller that will keep you on the edge of your seat until the film's end. Connery plays a law professor opposed to capital punishment who is persuaded to investigate the upcoming

Movie façade from *Wind Across the Everglades* filmed on location, 1957. Guest stars included Christopher Plummer, Burl Ives, Gypsy Rose Lee and Chokoloskee's "Totch" Brown. *Photo by Irvin M. Peithmann. Courtesy of Florida State Archives.*

murder conviction of Underwood, whose confession was brutally coerced by the chief detective, Fishburne. The nearby communities of Lee-Cypress and Ochopee were also used as backdrops in the film.

Then, in 1997, the historic Rod & Gun Club was included in the filming of *Gone Fishin'* with Danny Glover and Joe Pesci, with a small part by country music singer/songwriter Willie Nelson. This film follows the unending trials of Glover and Pesci and their bumbling exploits during an Everglades fishing trip, won in a contest. Additionally, both interior and exterior shots of the local historical Monroe Station, located at the junction of Tamiami Trail and Loop Road, in nearby Ochopee, are also included in the film.

The poaching of endangered orchids from the seventy-thousand-acre Fakahatchee Strand Preserve State Park, off U.S. 41 (Tamiami Trail) between Everglades City and Copeland, serves as the focal point of the 2002 film *Adaptation* starring film industry giants Meryl Streep, Nicholas Cage and Chris Cooper. The film highlights the true story of the illegal and rampant theft of orchids in this protected preserve by John Laroche and three Seminole Indians. It also depicts the incredibly lucrative business orchids remain even today. The film was itself an adaptation of author

Susan Orlean's 1998 book *The Orchid Thief: A True Story of Beauty and Obsession.* With the danger of real alligators here on location, the production company opted to create a faux air-conditioned swamp on a Warner Brothers back lot and filled it with assorted orchids, bromeliads and other Florida native plants to create the effect of being in Florida. Actual cameras came later for what's referred to as "second unit" footage, sans actors.

Now back to *Wind Across the Everglades.* The year was 1957, and for three months money was pumped into this little town of roughly seven hundred inhabitants. Some two hundred movie people invaded the town and rented every room in the historic Rod & Gun Club. All of this flash gave the local citizens a glimpse into the world of celebrity and filmmaking. Local chickens were given extra feathers in order to portray the egrets. Another interesting tidbit about the cast pertained to television actress Gypsy Rose Lee. She drove her Rolls Royce down from New York with her young son, three Siamese cats and an Afghan hound. The car broke down en route and had to be towed to Folkston, Georgia, located near the Okefenokee Swamp. These car repairs made her late to the set. Several of the actors and the Schulbergs attended the world premiere in Miami in August 1958, although no one from this crew was up for any spectacular roles in this film that was later deemed "for the birds," according to *Time* magazine.

HURRICANES IN THE LAST FRONTIER

Since the establishment of Everglade in 1928, there have been several critical hurricanes that have made an impact on its citizenry.

An unnamed hurricane (the practice of naming hurricanes began in 1953) in 1910 sent the local schoolhouse floating down the river, as depicted in a primitive sketch by self-taught artist and Everglades City pioneer Rob Storter. Other delightful images can be found in his historical account on life in the untamed Everglades in his book *Crackers in the Glade: Life and Times in the Old Everglades.*

On the morning of September 18, 1926, an unnamed hurricane hit Miami and by noon was battering Everglade. Storm winds blew the water out of the Barron River and Chokoloskee Bay and then surged back into the water-front town of Everglade with heights over eight feet. Those who decided to ride out the storm huddled together on the second floor of the Everglades Inn. They stood there helpless, watching the storm blow homes from their foundations. Other homes were literally blown apart from the

Everglades City cleanup following Hurricane Donna, 1960. *Courtesy of Florida State Archives.*

sheer force of the winds. Stories were told of the pastured cows that drowned because there wasn't an elevated shelter for them. And nearby Port DuPont, home of the repair complex for Collier's road-building equipment for the Tamiami Trail, was leveled.

Hurricane Donna scored a direct hit on Everglades City, Naples and Marco Island on September 10, 1960. Packing 160-mile-per-hour winds, the city would soon be inundated by eight feet of flood waters. "This hurricane packed enough energy to equal that of a hydrogen bomb exploding every eight minutes," according to Ron Jamro's special "Millennium" column on hurricanes for the *Naples Daily News*. Naples's landmark pier was demolished by the high winds and waves. And for thirteen hours straight, Everglades City was pounded, destroying both homes and businesses, causing more than $2.5 million in property damage. This storm would sadly be the final justification for the county's relocating the governing seat to nearby Naples.

While most areas of Collier County narrowly escaped the wrath of Hurricane Andrew on August 24, 1992, the storm left $34 million in destruction in its wake while causing long-term environmental damage along the coast.

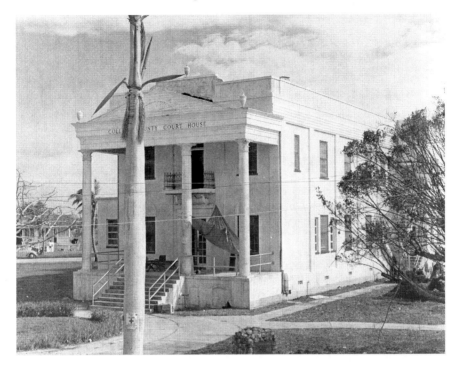

Everglades City Hall, following Hurricane Donna's wrath in 1960. *Courtesy of Florida State Archives.*

On October 24, 2005, Hurricane Wilma, a downgraded Category 3 hurricane, with 111–130-mile-per-hour winds, pummeled southwest Florida. While, miraculously, no one was killed, the eye of the storm passed directly over Everglades City and the surrounding areas of Chokoloskee and Plantation Islands, leaving a major path of destruction. Widespread flooding was reported, with up to three feet around the town circle, along with structural damage to several homes and a few totaled trailers as the souvenirs that Wilma left behind. The electricity was out for thirty-six hours in Everglades City. The telephones were out of service for three or four days, the cable about one week and the water about one day. About midday following the hurricane, the sheriff's office sent in deputies, who arrived in air boats, making the rounds and checking on every single resident who stayed behind. Food and water were the greatest needs.

Everglades City Hall—with its grand two-storied columned building that served as the former county courthouse, situated on the town's circle—had lost its roof, ceilings had collapsed and windows had been blown out, leaving

local authorities with no choice but to condemn the property. Just prior to the hurricane's final blow, renovation of the building that also houses a branch of the Collier County library, as well as a county clerk's office, was already underway, with plans to return it to its former grandeur. Time and the elements had not been kind to this old building during the past seven decades. It was in major need of repairs if it was to be saved. Who could have guessed that the devastating Category 3 Hurricane Wilma was the building's savior? The historic city hall was salvaged from the foundation with help from FEMA representatives, who were on location in Everglades City two days after the storm. The good news is that with FEMA's pledge of financial assistance, a once dilapidated piece of history has been saved. And that saving is priceless.

OPERATION EVERGLADES: LAST OF THE "SQUARE GROUPER"

Unfortunately, Everglades City, like many other small towns, has its not-too-colorful past, and I would be remiss if I didn't at least include a small segment on this dark chapter of our history. In previous sections, we've discussed a complete lifestyle change for many of the local people, particularly after the federal government came in and created the Everglades National Park, which opened in 1947. Little by little, the park completely restricted the local fishermen, until commercial fishing was banned altogether in the park by 1985. Gone were the old ways of hunting and fishing for survival now that the park was here to protect both the animals and fish. While I do not condone the actions that many local residents embarked on, I can understand how they could have gotten caught up in what was being touted as "easy money" for not much work, when they hadn't had any real work to do lately. It doesn't make it right, because it was against the law, but there just weren't too many other options available to them legally in order for them to still put food on their tables and pay their bills.

Collier County had been recognized as being the point of entry for drugs coming in from South America, according to former Collier County sheriff Aubrey Rogers, whose term as sheriff from 1975 to 1989 coincided with the height of the marijuana smuggling. More specifically, Everglades City and nearby Chokoloskee Island regions were a smuggler's paradise. The Ten Thousand Islands coastline, with its meandering creeks and mosquito-

infested mangrove islands, was the ideal place for reeling in "square grouper," as the compressed bales of marijuana were commonly called.

In the early morning hours of July 7, 1983, more than two hundred police and drug agents swept across Collier County in one of the nation's biggest marijuana smuggling crackdowns. The undercover operation drug bust netted twenty-eight people, twelve from the Everglades City and Chokoloskee area, with sixteen others in Naples and throughout Florida. In addition to those arrested, the agents also grabbed fourteen boats, assorted cars and trucks and two small airplanes, all allegedly used in the transportation of marijuana smuggling. "Few of the Everglades City's founding families have been untouched by the drug trade," according to *Miami Herald* staff writers Jeff Leen and Carl Hiaasen.

Posing as buyers, sellers and even boat handlers, the Drug Enforcement Administration (DEA) agents were able to infiltrate the small, tight community—where everyone knows your name and your business. Family ties are deep, going back generations. Up until then, the area had been pretty impenetrable to outside law enforcement. Because of its unique location on the fringe of the Everglades National Park, while bordered by both Collier and Monroe Counties, Everglades City has long been deemed an isolated area for various law enforcement agencies over the years.

For many, it was just a matter of time before their luck ran out. Lured into smuggling and a more lucrative lifestyle in the late 1970s, it was hard for them to keep their newfound wealth under wraps. Their transformation happened nearly overnight. They quickly went from dirt-poor, hardworking people to people of wealth. Pretty soon, Everglades City and the surrounding area began sporting new cars or sleek, overpowered boats gained from their new wealth. And additions to their homes were being built, or new construction altogether began popping up as well—many with swimming pools. It was this flagrant posturing that would upset the Collier County sheriff's offices and its Everglades substation lieutenant Charlie Sanders and his deputies as they tried to stop as much smuggling as possible. However, when those smuggling know the surrounding areas as well as they do from lifelong experiences, it was extremely hard for outside law enforcement to keep up with them, much less outsmart them at their own game. Pretty soon, word about all of the new wealth was heard throughout the chain of command before finally making it to the top.

Former Collier County sheriff Aubrey Rogers requested assistance from the DEA to help with the rampant drug flow through the coastal towns,

which resulted in a three-year undercover operation known as Operation Everglades. After the initial sweep in July 1983, DEA agents and local police conducted a second drug sweep a year later, in June 1984, called Operation Everglades II. With yet another 250 agents in town, this drug bust netted law enforcement another 12 suspects from Everglades City, Chokoloskee, Marco Island, Naples and even into Fort Myers. "Federal agents described this area as one of the most active drug smuggling ports in the Southeast," according to *Miami Herald* staff writer Donna Wares in July 1984.

"If convicted of these drug-trafficking charges, the defendants will face stiff fines, penalties, and possible forfeiture of a considerable amount of personal property. Additionally, charges named in these indictments vary with some defendants named in multiple counts of up to 18, and possible fines and prison sentences also vary according to the charges," as reported in the *Everglades Echo* on July 5, 1984.

While acknowledging that the drug trafficking hasn't been stopped entirely, Rogers is happy with the progress made thus far: "It has certainly been slowed up." Rogers went on to say that "this was one of the best large-scale operations in the country. We're thankful that the federal government has made a commitment to the drug problem and to this office."

CHOKOLOSKEE ISLAND

SMALLWOOD TRADING POST WITH INDIANS

Just off the kitchen, fly swatter in hand, sits Charles Sherod "Ted" Smallwood, early Chokoloskee pioneer and trading post owner. Wait, that wasn't Ted? Actually, no; it isn't Ted, but rather an incredible life-sized model of him, according to his granddaughter (and executive director of the post) Lynn McMillin. At the end of the trail four miles south of Everglades City, on State Road 29 in Chokoloskee, visitors can view the historic Smallwood store perched on pilings at the water's edge. Smallwood established the trading post and post office back in 1906, when trading with local Indians was a daily occurrence. Both the Seminole and Miccosukee Indians brought in their animal hides, bird plumes, fish and produce and traded for other goods until the Tamiami Trail opened in 1928. This trading post served as the cultural trading bridge between the Indians and the white man. Canoe trips of thirty to forty miles could often take days, and many times the Indians camped overnight, or longer, before continuing on their journey back home. The entire Smallwood family's life revolved around trade at the store, which remained open until 1982.

This historic step back in time allows one to view actual store ledgers lying on the countertops logging the daily transactions of the local settlers, when bread cost a mere ten cents. Furnishings and other memorabilia from that era are also prominently displayed. A large kitchen/cooking area, complete with table set for dining, welcomes weary travelers. An area where animal hides

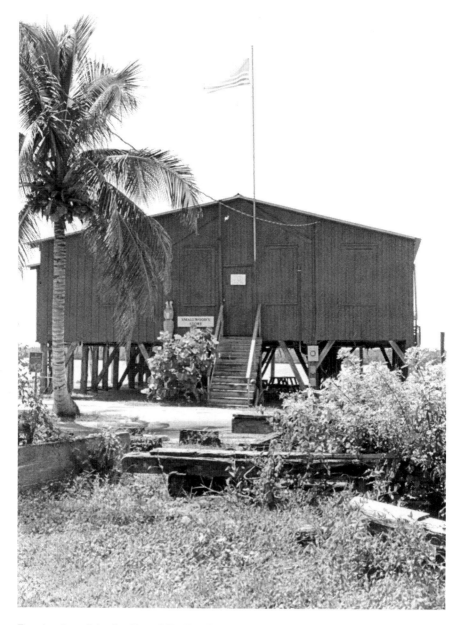

Exterior shot of the Smallwood Trading Post on Chokoloskee Island, 1994. *Photo by author.*

Chokoloskee Island

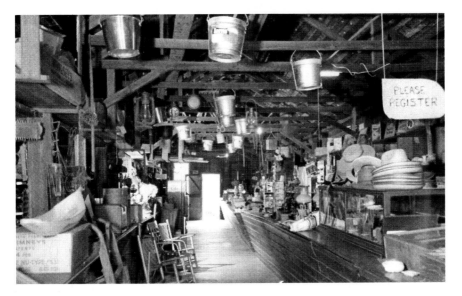

Interior shot of the Smallwood Trading Post, circa 1950s. *Courtesy of Chris Hancock.*

and furs used in trading once hung has now been redesigned and updated to allow for a VCR that plays various documentary tapes promoting the local community and its history.

Smallwood bought the property from the Adolphus Santini family, who were listed on various records as being the second family on the island. The 1880 records indicated that the Santini family held claim then to most of the island until 1899, when they left and sold their claims to Smallwood, making him the largest landholder on Chokoloskee. Through the incredible efforts of Charles Greenleigh "C.G." McKinney, a post office was established in 1891, even though at that time the island was known as Comfort. Keep in mind that mail originally came by boat from Key West, and then, as the railroad lines expanded into southwest Florida, it came from Fort Myers into Everglade and then again by boat until the causeway to Chokoloskee Island opened in 1956, bringing remote Chokoloskee and its roughly two dozen families within reach of the outside world. With the road came electricity, another boon to the locals since power previously had been produced by generators.

Smallwood built the current store in 1917. The building was moved six inches on the foundation in 1924, and the following year he had it raised on pilings. Smallwood relocated the post office, originally established by

McKinney in 1906, when he became postmaster until his retirement in 1941. Resourceful and enterprising, Smallwood was also blessed with a photographic memory. A farmer by trade, with a third-grade education, Smallwood quickly turned the store into the center of activity on Chokoloskee Island. He learned the Indian language and was so trusted by them that he kept their money for them at his store, which was called the "Indian Bank." Smallwood was a regular fixture in the store until his death in 1951.

When the store closed in 1982, it was subjected to both vandalism as well as the harsh Florida elements over the next several years. Granddaughter McMillin began her restoration crusade in 1990 following a preservation feasibility study that determined that the old store could indeed be salvaged. Thus began the arduous inventory, but it was ultimately a labor of love, since the store now serves as a time capsule of southwest Florida's pioneer history. The store was added to the National Register of Historic Places in 1974. And as a testament to its longevity, even Hurricane Wilma in 2005 could not tear it from its pilings—although the roof was damaged and the steps leading up to the front door blew away. Smallwood Trading Post is a lasting monument to the pioneering spirit of the Ten Thousand Islands.

CHOKOLOSKEE ISLAND SCHOOLS

Isolated from the rest of the world until 1956, when the causeway opened, the Chokoloskee community did not have continuously running schools or even a church for that matter. The first records of a school on the island were said to have been held in a Catholic mission. It was established to serve the children of farmers and fishermen who traded by sailing vessels from both Fort Myers and Key West. The first school was built in 1918 and was under Lee County governance and guidelines. Keep in mind, too, that teachers were also erratic with their own attendance, and many just simply could not and did not adapt to these outback conditions.

In 1924, pioneer columnist C.G. McKinney wrote, "Our schoolteacher…is going to give up her school today, it is too much for her nerves. She seems to be a nice refined body and we are sorry for her. She had a trying time here, but we can give her praise for her endurance." In Totch Brown's book, he relates to another column written in November 1924 by his Grandpa McKinney that noted, "We have…no school. We heard of a he-teacher who started down here and got as far as Marco

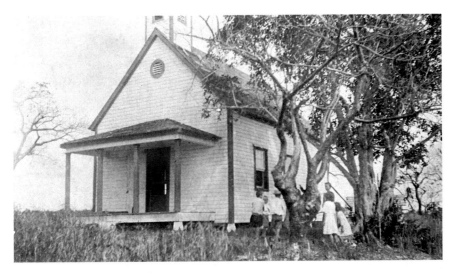

The first school built on Chokoloskee Island in 1918. *Courtesy of Florida State Archives.*

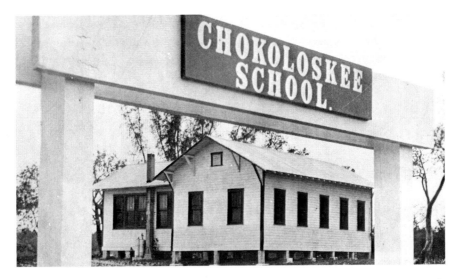

The second school built on Chokoloskee Island in 1957. *Courtesy of Florida State Archives.*

[Island] and found out he did not have his fighting spirit along; so he went back up the coast."

In the beginning, the local children only received an eighth-grade education; however, in the late 1930s, some began attending high school

in both Everglade and Naples. It wasn't until 1940 that a Chokoloskee graduate, Belle Thompson, received her diploma from Everglade.

The second school was built in 1957, and Mrs. Carl Webb of nearby Copeland, a descendant of the Lopez family, reminisced about attending school on Chokoloskee Island and told me that the teachers were permitted to actually live on the premises (most likely due to its remoteness). She also told me that Mrs. Daniels had been her teacher in the former school and that each row served as a specific grade.

CHOKOLOSKEE ISLAND CEMETERIES

Who knew that tiny Chokoloskee Island, with its roughly four hundred inhabitants, is home to not one but *two* local cemeteries? And I've even heard rumors of a third, although I didn't personally see it myself.

The Chokoloskee Cemetery, often called the Smallwood Cemetery by the locals, reads like a veritable who's who of hardy pioneer men and women who carved out their lives here in this remote region bordering the Ten Thousand Islands. Some of those pioneers include House, Demere, Hancock, Santini,

Headstone of Charles Greenleigh "C.G." McKinney, aka "the Sage of Chokoloskee," at Smallwood Cemetery, 1994. *Photo by author.*

McKinney, Brown, Thompson, Smallwood and many others. This roughly half-acre cemetery, with fewer than one hundred graves, is located on Smallwood Drive on one of the higher spots on Chokoloskee Island. It was donated by the late C.S. "Ted" Smallwood before he passed in 1951. The oldest headstone on record at the cemetery belongs to Atka Shealy, wife of W.G. Shealy, and dates back to 1901. The cemetery is still in use today by the descendants of these pioneering families who helped develop this area.

Imagine my surprise while researching this book to discover a second cemetery very close to the Chokoloskee Cemetery! I was so shocked to discover this small cemetery, having literally passed by it at least a hundred times since my first official trip down in 1993, when I began working as a reporter. No one ever mentioned its existence in all these years, but it has been there for a very long time. According to the dates inscribed on the headstones, Louis Lopez died in 1901. After accidentally stumbling upon it, I began (in true reporter fashion) making a few inquiries that led me back to the Carl Webb family, of the Win-Car store. The tiny, solemn cemetery sits on a hill behind a black wrought-iron fence and on a road that bears

Chokoloskee pioneer Mamie Smallwood's headstone at Smallwood Cemetery, 1994. *Photo by author.*

The oldest headstone (1901) placed at Smallwood Cemetery belongs to Atka Shealy, 1994.
Photo by author.

Lopez Cemetery on Chokoloskee Island; the Louis Lopez headstone, buried 1901. *Courtesy of Collier County Historical Research Center, Inc.*

its name, although it is misspelled. The name should read "Lopez," not "Lopes." Having first met Margaret Webb, wife to Carl and mother to Jim, in 1993 when I interviewed her for an article for the local newspaper, I was delighted to hear she was still alive and still sharp as a tack when I phoned her while researching this book. She once more very graciously invited me into her home one afternoon and regaled me with her family's history, tracing it all the way back to Spain. Mrs. Webb gave me her permission to include the photo here in my book, knowing that I was writing about the history of the area. She also told me that she grew up on Chokoloskee, which was yet another delightful surprise to me.

And the rumors I'd heard about another cemetery on Chokoloskee Island? Well, who knows for sure? But there might actually be some credence to that tale, because I was also told that the bodies were buried and then concrete was poured over them so that when the area flooded, which it does quite frequently, those laid to rest would not accidentally resurface.

Not to be outdone, over in Everglades City just off the Barron River stands yet another cemetery, accessible only by boat. This small cemetery

is the final resting place for many in the Brown family—Totch Brown's family to be exact—and a few other pioneer families. Be sure to let me know if you do hear of any other cemeteries down here, so I can put them in my next book.

CHOKOLOSKEE CHURCH OF GOD: NINETY-SEVEN YEARS OF MINISTRY

The Chokoloskee Church of God was established in 1913, some forty-two years before the causeway would reach the mainland, bringing the outside world, with its good and bad, to the small island. During these past ninety-seven years, the parishioners have seen many itinerant pastors come and go, along with the occasional resident minister. According to their records, it appears as though they have had about two dozen pastors during this time and up to their present-day Reverend Morris Dantin, who arrived in 1995.

Historical records showed that following the very first revival held in 1913, forty-two people were baptized at McKinney's Landing, including the following:

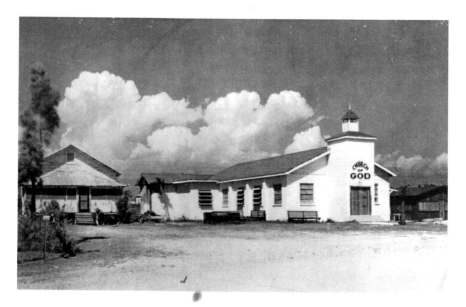

The Chokoloskee Church of God, established in 1913 and still ministering to the local community after ninety-seven years. *Courtesy of Chris Hancock.*

Rob & George Storter [brothers]
Nancy Storter [mother]
Charlie & Lillie Johnson
Grandma Susan McKinney [one of the first converts]
Mrs. Jim Howell
Lula Howell
Walter Howell
Mr. and Mrs. Frank Hamilton
Exie Hamilton
Emma & Bill Gardiner
Evelyn & Winnie Gardiner
Minor Johnson
Mac Johnson
Dexter Hamilton
Rob & Jim Thompson
Henry & Molly Smith
Aunt Tuggie Brown
Bessie, Ethel & Clarence Brown
Mrs. Henry Thompson
Ida & Alfonso Lopez [Ida was one of first converts]
Sinclair Demere
Phelanie, Annie & John Daniels
Alice Smith
Ellen Smith
John Matthews
Alice McKinney Brown
John Brown
Kathleen McKinney
Tant Jenkins
Harvey Daniels

According to a passage from Charlton W. Tebeau's book, *The Story of Chokoloskee Bay Country*, he states that C.G. McKinney claimed to have given the lot for the church, along with the bell and the lumber. In Totch Brown's book *Totch: A Life in the Everglades*, he reiterates that "Grandpa McKinney gave the church an old brass bell. He also gave part of the land the first church was built on, around 1900, and the more modern one they have now is on the same spot."

The original church was destroyed by a hurricane and replaced with another wooden structure. It was replaced in 1961 with the present concrete building. Apparently, this was the only church without a pastor in the area in 1923, according to Reverend James L. Glenn.

When Hurricane Wilma hit the island in 2005, with its 131-mile-per-hour winds, it blew the church steeple off the church. During the subsequent cleanup efforts, the steeple was found about two blocks away, but the interior bell was missing—another part of history gone. A new steeple has been replaced, along with new pews, newer vans and new roofs for the church, parsonage and annex.

Pastor Dantin told me that this was a really supportive congregation and added that they were quick to respond to any type of emergency. In addition to their own local ministries, the 170-member congregation is faithful in their support of feeding pastors and their families during their mission trips in foreign countries, supporting our soldiers in Iraq and sponsoring Bible school student scholarships.

Life does indeed go on in this tiny island, and I imagine that they will be around another one hundred years, God willing, because in continuing with their rugged pioneer spirit, they just keep going and going and going.

CHOKOLOSKEE PIONEERS

C.G. McKinney: The Sage of Chokoloskee

One of Chokoloskee's early pioneers was none other than Charles Greenleigh McKinney, known as "C.G." McKinney, who was born in Danville, Georgia, on August 8, 1847. There seems to be no record of his life as a child, other than that his family moved to Florida in 1854. At seventeen, McKinney was conscripted into the army and served with Captain Hendry's company at Fort Meade, Florida, during the Civil War. Following the war, he went back home to farm cotton and "moonshined" on the side for a few years.

After the war, McKinney went to Texas in 1869 and was paid thirty dollars a month in gold for his carpentry skills. While in Texas, he roomed with an English doctor, who taught him about medicines and midwifery, which would come in handy after moving to Chokoloskee.

Arriving back in Florida, he homesteaded 160 acres on the Santa Fe River in Columbia/Alachua County. He later sold 120 acres but kept the remaining

40 acres that was on the river. He sawed lumber for the SF&W (Savannah, Florida and Western) Railroad. Additionally, McKinney ground corn and operated a cotton farm while also running a grocery and dry goods store. Eventually, McKinney sold out and moved south, to Chokoloskee, for health reasons. While reminiscing with Florida historian Charlton W. Tebeau, McKinney attributed his long life and vigorous health to the simplicity of life on the frontier.

Upon his arrival in the Everglades, McKinney first lived on an island on the Turner River, which would later be renamed McKinney Island. Here he grew tomatoes, eggplant, cabbage, cucumber and bananas; he also built a sawmill. At that time, Chokoloskee Island still belonged to Monroe County, and Key West was the governing center. He learned how to trap alligators for their hides.

Pioneer C.G. McKinney, "the Sage of Chokoloskee."
Courtesy of Collier County Historical Research Center, Inc.

When McKinney arrived on Chokoloskee in 1886, formerly called Comfort, he opened a general store and later opened a post office—which was established on November 27, 1891—becoming Chokoloskee's first postmaster; he was commissioned on June 30, 1892. He shared with Tebeau that he recalled two Catholic families on the island when he first arrived, those being the Santini brothers, as well as the Murphys and John Brown and family. Ted Smallwood arrived on the island more than a decade later in 1897.

It appears that there wasn't much that McKinney couldn't do, having worked as a carpenter, midwife, farmer, store owner and then postmaster, but back in those days one had to be pretty versatile in order to survive.

His slogan to customers became known far and wide and was posted in the store. It read: "No Banking, No Mortgaging, No Insurance, No Borrowing, No Loaning. I must have cash to buy more hash."

It was here on Chokoloskee Island that McKinney would practice his midwifery for fifty years. He was the nearest thing to being a doctor in this remote region, save for the few itinerant doctors who made their rounds throughout the state. He was registered with the board of health in Jacksonville, Florida. Many birth certificates of those children born on the island bear his signature, including his grandson, Loren G. "Totch" Brown. The locals relied on him for medical advice. He also extracted teeth when necessary. In addition to his success with establishing the post office here on Chokoloskee, McKinney was also instrumental in establishing both a school and a church on this island, donating both land and the bell for the latter.

Genealogy records show that McKinney married Martha J., a widowed mother of two, and then later he married Martha Susan in 1886 in Key West, and they had four children, all born on Chokoloskee.

McKinney would become well known as the "Sage of Chokoloskee" through his penned columns, touting life in this remote region, with its hardships and good times, coupled with his humor and quick wit. In these very ambitious weekly columns, first published in the *American Eagle* located in Estero, McKinney wrote under various pen names, such as "Big Gov.," "Optimist" and "Progress," among others. He served as a faithful correspondent to the *American Eagle* for nearly twenty years. His columns were also found in the *Collier County News* and in as many other papers as he could get to publish his works. His columns had several recurrent themes, which included food, the foibles of his friends and neighbors and "low bush lightning." McKinney also made mention of mosquitoes, which he dubbed "swamp angels pointed on one end." I've taken the liberty to share a few of

Chokoloskee Island

American Eagle

Screams for Lee Co., in Particular and Florida, in General

ESTERO, FLA., OCT. 21. 1926 No. 2:

da

Strictly Native
Plant Lovers
-owth.

yes with a
trees, to
gives many
s his ears
rious har-
d! what a
Thou made

large and
an Ameri-
ce the dis-
most all of
general or
who have
"The ear-
lorers were
aintance of
zed by the
naturaliza-
ickly Pears
ern Africa
others be-
ern Africa,
Australia"

'acti native
l from the
o the most
plants we
or interest
to class of
of bloom
general fa-
qual them,
ot fashion-
gush over
approach
when they
the purse
of Orchid
st a shud-
ue form of
dy find lit-
g colors of
l gardeners
ey are naa-
se for cut-
for bedding
e.1
few select
ity of their
their spiny
their gor-
can recol-
ly life than
n groups of
ind Echino-
om in the
s, or when
the large,

hardy here, while the majority of them are killed outright by a heavy freeze. I often have saved the lower part of the stems by banking them with dry sand. This is easily done in the case of species of Cereus and Pereskia, but impossible with the Epiphyllums, Phyllocactus and Rhipsalis which I always have grown as epiphytes on the trunks of Cabbage Palmettos, Coconut and Date Palms. In extreme South Florida all are perfectly hardy.

trunks of various Palms. Small pieces can be easily wedged in between the old leaf-remnants and the trunk where they soon strike roots. If planted in pots all form beautiful ornaments on verandas or in rooms. The pots must be comparatively small, and must be filled at least one-third with broken pot-sherds or broken shells. The best soil consists of equal parts of sand, good loam, leaf mould, and broken pieces of old dry cow manure. The drainage must always be perfect, or

Sage of Chokoloskee Dies Suddenly

It came as a great shock when we learned on Monday of this week of the death of C. G. McKinney which occurred Saturday morning on the dock at Everglades where he had gone with his motor boat for a load of freight for his store at Chokoloskee. Under the nom de plume of "Progress" Mr. McKinney had served faithfully as correspondent for The Eagle for nearly twenty years, rarely ever missing an issue, and by his optimism, quaint philosophy and dry humor had become widely known, his Chokoloskee notes being often quoted by other papers. His life as a pioneer had been an eventful one and several months ago we suggested that he write his biography for The Eagle, which he accordingly did, little thinking that publication of its last chapter would be almost co-incident with the close of his earthly career.

Mr. McKinney was hard hit by the hurricane, his little store being demolished with considerable loss of stock. The real cause of his death is not known at this writing, but it is believed that he had over exerted himself in endeavoring to set things to rights after the storm. He is survived by a widow, a son and daughter living at Chokoloskee who have our heartfelt sympathy in their hour of bereavement.—Editor's Note.

Storm Resisting Tree:

Care in Planting Now Will Mean Lasting Shad
Beautifully Lined Streets for South Florida Cit
Trees Named Which Will Aid Rapid Recover;

It is one thing to talk about a tl and quite another to put it into ir ligent execution. One of our ser drawbacks in the proper planting our highways is the lack of the r kind of plant material to work w People plant, as a rule, trees that available at the local nurseries. the absence of the bucida in suffic numbers to plant out an avenue, r people, in all probability, will cont to plant the pithecolobium, becaus is easily obtained on all sides. parent trees are here, and they l an abundance of seed, which sp readily and grow like weeds.

The only way that we can prev a repition of the upheaval of street trees on Brickell avenue, Uk and numberless others, is to take finite steps in that direction. I courting future disaster to leave planting of our streets and aver to the hit or miss effort of subdivic and property owners, ignorant tropical trees and backed only by commercial nursery man. It is a c consideration too serious to be ign or treated lightly by the city of Mi and the outlying districts.

It has been said that the bu tree, or black olive, as it is someti called, is destined to be to St Florida what the elm tree is to I England. It is a moderately la spreading tree of bending nature, attractive evergreen foliage. Its right growth is an added feature, the fact that it requires no pru is an important point where upk has to be considered. The bucid not the only tree of worth for region, but it is one that can be pended upon in time of sti Streets lined with the bucida woul well shaded, dignified and very b tiful. Seeds of the bucida tree ma obtained in Cuba.

What a splendid project it woul for the city of Miami to send so one to Cuba for the seeds and r the bucida tree in sufficie t qua ties for adequate street planting. undertaking of this sort would k definite step toward the permai rehabilitation of a truly gre Miami. A city through which a tr storm might blow, with greater less intensity, and her trees rer intact. A city which would rer smiling, because she was prepared

Front page from *American Eagle*, Estero, Florida, announcing C.G. McKinney's death on October 16, 1926. *Courtesy of Alvin Lederer.*

his more priceless musings that were compiled by the *Collier County News* and written about in an article dated February 1953.

His November 6, 1924 column read:

> *Fishing is good. Bootlegging good. Moonshining on the draw back, the Satan Angels seem to like the imported stuff best. The Newport has not returned from Key West yet; we can't learn whether she sunk or is on top or not. We have no preacher yet but the folks is getting along about as well as ever. We have no school either, we don't see or hear any prospects of anyone coming to hold the school down. Mrs. C.G. McKinney is filling another contract for 10,000 grasshoppers, the school children catches them for her and it has a tendency to keep them out of other mischief.*

His January 24, 1925 column read:

> *We have no preacher yet and we have had no booze either this week. Mr. D.R. House has just returned from a business trip to Fort Myers. Mr. C.A. McKinney is putting a small addition to his house. Our old hens have been so everlasting contrary and won't lay. We are selling them now to the Everglades folks for a dollar and a half each, and try to get pay for some of the high price grain they have been eating. They are very fat and a lot of flesh in them old Rhode Island Red Hens. The old schooner Newport has not returned from Key West. She has decided to make a try monthly schedule; try last month and come this month.*

I'll close with an undated comment that read: "We had an eye carpenter with us but most of us can see well enough, in fact some can see too good because they see the faults of others and not their own."

Sometime during 1926, the *American Eagle* requested an autobiography of McKinney, and the publication unknowingly coincided with his unexpected death on October 16, 1926, in Everglades City just after the recent hurricane. He was buried in Chokoloskee Cemetery the following day on October 17, 1926.

His daughter, Willie Corrinne McKinney, penned these words upon his death. "'Progress' has departed. The correspondent of Chokoloskee has written his last news item. He was only an aged and obscure storekeeper on an unknown village on the edge of the Everglades yet thousands who have read his unique reports and observations will feel a pang of sorrow at his death."

Chokoloskee Island

The Charles Sherod "Ted" Smallwood Family

Four miles south of Everglades City, across the causeway built in 1956 that brought accessibility to this small island, lies Chokoloskee, with its roughly four hundred residents. Chokoloskee is an old Seminole Indian name meaning "Old House." While the land in this area is very low-lying, Chokoloskee Island reaches twenty feet above sea level, due to its shell mounds that were built more than two thousand years ago by the Calusa Indians. Historical records show that Chokoloskee Island was inhabited by Indians for more than 1,500 years before the European explorers reached the area. The island was indeed quite isolated, first belonging to Monroe County, with its county seat in Key West. In 1887, Lee County was established, and its county seat was located in Fort Myers, yet another ninety miles in the opposite direction. Collier County wouldn't be established until 1923, and its original county seat would be in nearby Everglade—as it was called until its incorporation in 1953, when it became Everglades City.

Modern-day descendants of the Smallwood family tell us that Chokoloskee Island was settled in 1874. The second family on the island was that of Adolphus Santini, and by 1880 they held claim to nearly the entire island. Two years later, the island boasted five families, including two of the Santini brothers. Farming and fishing kept these early settlers busy nearly all day but also fed.

A post office was established due to the efforts of Charles Greenleigh "C.G." McKinney's letter-writing campaign over the years. At that time, the island was called Comfort but changed to Chokoloskee in 1891. It was also in 1891 when Florida-born (from Columbia County in Lake City) Charles Sherod "Ted" Smallwood first visited Chokoloskee, moving around a few years before returning and finally settling down in 1896. The Santinis left the island and sold their claims to Smallwood in 1899, making him the largest landholder on the island.

After marrying Mamie House in 1897, the two moved into a two-room house on the east side of the island. A decade later, they opened a store in their home. After another decade of saving, Ted bought the lumber and built the trading post in 1917, which is still in existence today. Smallwood personally ran the trading post for thirty-five years, until his retirement in 1941.

Mamie and Ted reared six children that included Thelma, Marguerite, Robert, Glenn, Ted Jr. and then Nancy—although Nancy hadn't been born when the photo here was taken. Thelma picked up the reins from

Chokoloskee pioneers Mamie and Ted Smallwood, 1936. *Courtesy of Florida State Archives.*

her father and ran both the store and post office, never marrying, as did her siblings. Thelma's life was the store until she, too, passed in 1984. Marguerite married Fred Williams, and they reared five children. Robert married Eleanor Cleveland, and they reared two children. They built and managed the Parkway Motel, also located on Chokoloskee Island. Glenn married Dorothy Pleamon Goff, and they had four children, while living in Everglades City, where he was a charter boat captain. Ted Jr. married Clara Thompson, and they also raised four children. He, too, was a charter boat captain, and together with his brother they ran Everglades Small Boat Dock in Everglades City. Ted Jr. once held some considerable landholdings in the area, including the Port DuPont area to the right of the Barron River Bridge as you enter Everglades City. The youngest child, Nancy, met and married

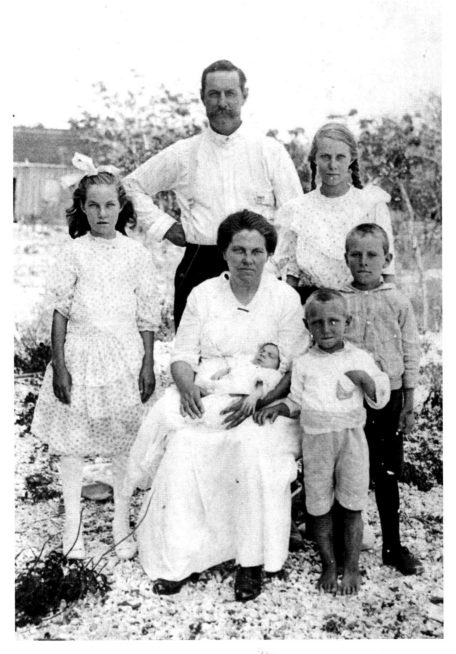

Mamie and Ted Smallwood and five of their six children: Thelma, Marguerite, Robert, Ted Jr. and Glenn—Nancy had not yet been born, 1917. *Courtesy of Chris Hancock.*

A.C. Hancock, and they reared three children. They opened and operated the Blue Heron Motel for more than thirty years.

Both Mamie and Ted are buried at the local Chokoloskee/Smallwood cemetery—Mamie passed in 1943 and Ted in 1951. Sadly, neither lived to see the completion of the causeway that would bring the world to this remote island. Mamie had been a champion for the causeway and wrote letters on behalf of its construction. Thelma is buried in Naples, as is Marguerite. Robert is buried on Chokoloskee. Glenn is buried in Naples. Ted Jr. and his family are also buried in Naples. The last of the original Smallwood children, Nancy, passed in 2006 at eighty-four years, and she is buried on Chokoloskee alongside husband A.C.

A.C. Hancock: School Boat Builder

Born on Sand Fly Pass in the famed Ten Thousand Islands, Alton Carlton "A.C." Hancock was born in April 1922, the oldest son of Freda Boggess, the great-great-granddaughter of F.C.M. Boggess, a veteran of four wars. Hancock later attended and graduated from Everglades High School with

Chokoloskee resident Alton Carlton "A.C." Hancock served on the USS *Erie* until its fateful sinking off Curacao in 1944. *Courtesy of Chris Hancock.*

his fellow classmates, Madison McKay, Billy Powell, Leola McKinney and Fanny Evelyn Dewar, all five of them in 1940.

Hancock's children remember him telling stories of his own youth and the memory of his father's blindness. Because of his blindness, Hancock would take him to a nearby island so that he could get in a boat with his fishing partner, Isaac Williams. After leaving the dock, Hancock would play with his friend Bubba, and after playing for a while the two boys would settle in for the night under the kitchen table with the family dog. They would sleep there until the fishermen returned with their catch. Hancock would then drive his dad back to Everglade, where he would help him with the fish and then dress for school.

Hancock and his brother Dennis joined the U.S. Navy in 1941, but they were soon separated. Hancock was stationed in Norfolk and then later Portsmouth, Virginia, before boarding the USS *Erie*, on which he served for three years and eleven months, until its fateful sinking off Curacao in 1944. Dennis was stationed on the USS *Harold* and took part in the invasion of Luzon, in the Philippines.

Following his return from the service, Hancock married his sweetheart, Nancy Smallwood, daughter of trading post founder Ted Smallwood and his wife Mamie. They were married in 1946 at the Smallwood family homestead, and they reared a family of three children: Chris, Lynn and Rex. They were married for more than fifty years, celebrating that milestone occasion in 1996 with family and friends.

Back in 1953, the Collier County School Board decided to combine the Everglades City School and the Chokoloskee School. This meant that those students living on Chokoloskee Island would now head over to Everglades City—by boat, since the causeway had yet to be built. The school board put out a bid for a boat to be built that would transport students from fifth through twelfth grades to the new school. The younger children continued to attend school in Chokoloskee. Hancock was awarded the contract, and he set up his workplace at the boat ways next to the Smallwood Trading Post, owned by father-in-law Ted Smallwood. He spent the next three months constructing the craft. The interior of the boat had a bench on each side with a table in the middle, and it was painted white. Gus Rewis served as the captain of the school boat, which ran until the causeway opened in 1956.

Shortly after the causeway was completed, Hancock and Nancy established the Blue Heron Motel, a small motel located at the corner of Mamie Street and Chokoloskee Drive that they managed until retiring in

The school boat, built by A.C. Hancock in 1953, transported local students to Everglades City until the causeway was opened in 1956. *Courtesy of Chris Hancock.*

1999. While still operating the motel, Hancock lent his support to the local community and served for twelve years as a Collier County commissioner (1960–72), initially beginning his service in Everglades City and following the post into Naples after Hurricane Donna's damages in 1960 moved the county seat from down here. The American Red Cross recognized Hancock for his outstanding service to the community at the time of the disastrous hurricane. Passionate about politics, Hancock also served on the Bank of Marco Board of Directors and explained to a reporter once that he wanted to serve on the board to make sure that "people came first."

After his service as a county commissioner, former sheriff Doug Hendry asked Hancock to work for him as a deputy out of the Everglades City substation. Hancock agreed, with the stipulation he serve in the marine patrol—Hancock's field of expertise. Having lived here all his life, the Ten Thousand Islands were literally his backyard, and he knew them like the back of his hand. Hancock worked for the next twelve years, retiring as a corporal in the marine patrol division.

Sadly, just twenty-nine days shy of his eighty-second birthday, Hancock passed in 2004 and was buried at the local Smallwood Cemetery. Two years later, wife Nancy would pass in 2006 and was laid to rest beside her husband of fifty-eight years.

Colorful Characters

Loren G. "Totch" Brown

"You'll want to write a story about me," he said to me over the phone.

"Oh yeah?" I replied, "and why is that?"

"Because I just wrote a book on my life and this area, and everybody will want to read it," he said with so much enthusiasm you could actually hear it in his voice.

"Really?" I asked again, totally shocked by this man's brazenness.

"Really," he replied.

"And your name again?" I asked.

"I'm Totch Brown," he answered, like that was supposed to mean something to me, and it would later.

We hung up soon after scheduling a date to meet the following week. I distinctly remember while driving the forty-five-minute trip to Chokoloskee to meet him wondering how I was going to "let him down gently." How could I tell him that not everybody would want to read his book? At least in my opinion. But that was before the boat ride—and before I had read his book!

After knocking on the door, there stood the late Totch Brown in all his glory, brown as a berry—as my grandparents used to say—and grinning from ear to ear. The first thing out of his mouth was, "Hi, I'm Totch," followed quickly by, "You're new to this area, aren't you?" He turned to finish making his peanut butter sandwich and grabbed his water and hat while whistling for his dog Troubles, and we were quickly out the door. He laughed as he told me that all of his dogs were named Troubles because it saved him time trying to remember their names.

Within minutes we were out on the water, and he was taking me through the famed Ten Thousand Islands, pointing out mangroves, plants and wildlife all native to the area. He recalled both his coon-hunting and gator-hunting days and admitted his part in killing more than three hundred alligators in two nights with his brother Peg; he told me all about the tasty "Chokoloskee Chicken" they used to eat, which was really white ibis and very much protected today. It was indeed a beautiful sight, and for the next few hours I was given an incredible tour by a local native, a tour of his own personal backyard.

Did I mention I can't swim? Here I am, the new reporter from the *Everglades Echo* newspaper on a boat heading out into the Ten Thousand

Chokoloskee native Loren G. "Totch" Brown in the Ten Thousand Islands, spinning yet another yarn, 1994. *Photo by author.*

Islands without a cell phone (the year was 1993) and with a man I barely knew, having just met him that morning. Who knew if I'd ever be heard from again? Could he be trusted, I wondered—too late, as we were already out on the water. Thankfully, I didn't have to wonder too long, because once

we rounded the Chatham Bend, he pointed out his youthful homestead and began one of his many colorful yarns that day. He pointed out the oyster shell mounds on which the Calusa Indians made their homes centuries ago. He pointed out the old trading post where "Bloody" Edgar Watson was said to have been gunned down on the banks of the Smallwood Trading Post. He passed by Moonshine Key where he had helped his father run shine during Prohibition. He had a captive audience in me, and the day got away from us before we knew it. I remember not wanting the day or boat ride to end as we headed back to the dock. I was also painfully embarrassed to admit that while I had already lived in this area for the past decade, I knew nothing about it. (My two previous visits to Everglades City had been brief.) Totch Brown had not only given me an up close and personal tour of this beautiful area, he had also unknowingly piqued my interest in the Everglades. I was hooked!

For the next three years, I had the privilege of learning more about Totch, and this area of southwest Florida, before he passed. This natural-born storyteller had many stories to tell, and for several years he compiled them—all with a no. 3 lead pencil. His bestselling book, *Totch: A Life in the Everglades*, was published in 1993 by the University Press of Florida in Gainesville—and it is still sold in stores and online even today.

Born on Chokoloskee Island in 1920, Totch only left the island twice: once when he joined the service during World War II and again in 1984 when he went to federal prison for tax evasion stemming from his marijuana smuggling. His grandfather, C.G. McKinney, served as midwife at his birth. Totch was the fourth of five children born to John J. and Alice Jane (née McKinney).

Totch bought his first boat at age thirteen and spent most of his youth with his father and brother "Peg" hunting, fishing and trapping along the Chatham Bend area, long before the formation of the Everglades National Park. Totch's father was a professional hunter, taxidermist and boat builder who added to his income by making moonshine during Prohibition. His family lived off the land—their homes never more than island camps and tar paper shacks inundated with mosquitoes—"swamp angels," as his grandfather McKinney called them. Yet even in this remoteness and simplicity, his father owned a camera that didn't get past this writer's eye when I first read Totch's book, which included a photo of his father taking a picture of himself. Even today, I still cannot get over that image—it just seemed that a camera was such a luxury in that untamed wilderness.

Totch married Estelle Demere, whom he refers to as his "Queen of the Everglades," in 1938. She, too, was a native like Totch, having been born on a houseboat at Sand Fly Island. She was fourteen to his eighteen, and eleven months after their marriage the first of five children was born—three of whom are still living. World War II took Totch away from his homeland, and he returned with both a Bronze Star and a Purple Heart for his service during the Battle of the Bulge in 1944 with the Eighty-seventh Infantry.

After his return from his military service, Totch and many other locals found it more and more difficult to make a living off the land, as they had in generations past. When the federal government took over management of the Everglades National Park, there were now numerous restrictions imposed on them. No longer could they hunt and fish as before, which meant that they would have to find other ways to survive. Over the years, Totch had made a living as a fisherman, gator poacher and crabber. He even had a bit part as an extra named "One Note" in Budd Schulberg's *Wind Across the Everglades*, filmed on location, back in 1958.

Another colorful chapter in Totch's life found him hauling marijuana in the late 1970s as a means for survival. Following open-heart surgery and faced with more than $40,000 in medical bills, as well as advice from his doctors to stop all manual labor, he began smuggling. "I made $15,000 for my first night's work," he recalls—and adds "in cash." "All the same, hauling marijuana wasn't really my way of life." During his short-lived "pot-hauling" days, Totch would personally go to Columbia in one of the four shrimp boats he owned. "The trip would take eight days if all the conditions were right," he said matter-of-factly. Ironically, Totch was arrested for tax evasion and not smuggling. "It wasn't an alligator in the Everglades that caught me, neither was it a Park Ranger, nor the Coast Guard, but the I.R.S.," Totch shared in his book. Figuring by late 1982 that the dust had settled from the pot-hauling, he wasn't expecting a knock on the door. Two men in their tell-tale suits with ties and badges in their hands made him instantly suspicious, but he quickly showed them the way out the door they had just come through. Totch found out that the government was running the biggest investigation ever on marijuana smuggling in southwest Florida—more specifically, in the areas of Everglades City and Chokoloskee. Not only did he pay a hefty fine of more than $1.5 million in cash and assets, he also served fifteen months in prison for not ratting out his friends.

At age seventy-three, with a seventh-grade education, Totch began writing his book with the purpose of setting the record straight. "I didn't write the

book for the money; but rather to leave the history with the people here before I die," he stated. His story begins with the settling in the Ten Thousand Islands back in the 1880s. These untamed lands attracted rugged pioneers as well as outlaws, including plume hunters, bank robbers, murderers and later moonshiners and rumrunners. This was the untamed Everglades, far different from the Everglades we know today.

"While life in the Everglades was no picnic, the privilege of living a free life that close to nature was worth all the hardships that came with it," Totch says, "like coping with alligators, panthers and rattlesnakes on muddy lands filled with poison ivy, spiders and mosquitoes—so thick you could rake 'em off your brow by the handful."

An environmentalist in his latter years, he shared a love for this land. I can still hear Totch's famous line that I heard on so many occasions: "To my way of thinking, I just never saw a place my entire life that hit me like this one. There's no place like home, and buddy, this is home to me."

Another decade came and went. Totch passed in 1996 at the age of seventy-six, and while I haven't been out to the Ten Thousand Islands since our last ride together just prior to his passing, I still have many fond memories of my time spent in this area, which is why I decided to write this book with the hope of piquing your interest in this remote region, the Last Frontier.

Edgar Watson and Big Six Hannah

Now who hasn't heard the old tale about Edgar Watson being gunned down by half the men in town on the banks of the Smallwood Trading Post and Chokoloskee Bay back in the early 1900s? The tale was made famous in Peter Matthiessen's 1990 fictionalized novel, *Killing Mister Watson*. The novel is set in the Florida Everglades of a century ago. The Ten Thousand Islands country has been described as the perfect haven for outlaws, and that would most certainly include the famed Edgar Watson.

Rumor has it that Watson was an outlaw, killing more than fifty people, mostly his hired help, so that he didn't have to pay them. Stories abounded about dead bodies popping up in the deep waters of the Ten Thousand Islands. And then there were the rumors of the dead bodies buried on his property. Watson is also reputed to have killed the celebrated outlaw Belle Starr in Oklahoma over a disagreement. Just days before her forty-first birthday in 1889, Starr was riding home from a neighbor's house when she was ambushed. Watson had been one of her sharecroppers and was soon a suspect in her death, as an escaped

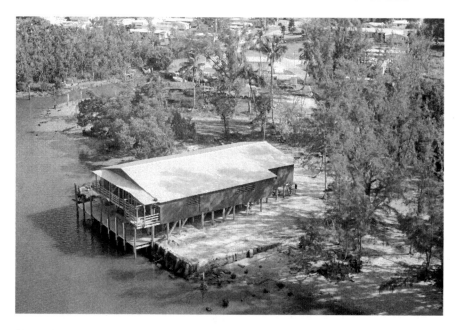

Site of *Killing Mister Watson* (from the early 1900s story) at the water's edge, behind the Smallwood Trading Post; aerial shot in 1994. *Photo by author.*

murderer from Florida with a price on his head—a powerful motive. He was afraid that she was going to turn him in to the authorities. With no witnesses, Watson was acquitted of her murder and it remains unsolved today.

When Watson arrived in this region in the late 1890s, the rumors of his killing Starr made everyone just a bit leery of him, and he was viewed as someone of questionable reputation. He was also known to have a violent temper. On the surface, he appeared to the locals to be quite successful—enough to build himself a two-story frame home high on an old oyster shell Indian mound on Chatham Bend. He also hired help to keep his many ventures running smoothly. In addition to his sugar cane farming, Watson raised tomatoes, potatoes and other vegetables that were shipped to Key West; he also made moonshine. He would frequently be seen bringing various people to his place to help with the work; however, no one ever recalled seeing anyone leaving on their own two feet. One of those people Watson brought in to work was a woman by the name of Hannah Smith, or "Big Six," as she was called. Hired on because it was said that she could do the work of a man, she was hired by Watson to chop firewood for his syrup mill but would soon become one of his victims.

Locals became even more suspicious as more bodies were discovered; in 1910, when yet another body was discovered in the shallow waters of Chatham Bend, the neighbors were alerted. Watson denied the killings, even though community sentiment ran against him. During a confrontation outside the Smallwood Trading Post, it was said that Watson became enraged at the group that had gathered at the water's edge to accuse him of this murder. Watson pulled out his shotgun and pulled the trigger, but the shells in the firearm were wet and failed him. In an instant a hail of bullets was flying through the air, gunning him down. One story said that they stopped counting the bullets once they had filled an empty coffee tin. The "reign of Bloody Watson" was over. Even though Ted Smallwood, proprietor of the trading post, hadn't seen the shooting, he went outside after it had quieted down and found Watson lying dead on the banks. He said, "They carried him out to nearby Rabbit Key and buried him." Some said that they even put a large stone over his grave—just in case! Smallwood continued: "Even though everyone was called into Sheriff Tippins court the next day, they soon turned everyone loose and no 'one' was ever charged with his murder. Later Captain Bill Collier went out to get him and take him to Fort Myers and bury him, where he lies today."

But what about the story of the Ox Woman, and how does this relate to Watson? Her real name was Sarah McLain, and she was a six-foot, four-inch "giant of a woman" and one of four "giant" sisters that included Hannah Smith (Big Six), Mrs. Lydia Smith Crews and Nancy Smith (Big Nancy). Their father was rumored to have been the biggest man in Racepont, Georgia.

The Ox Woman was seen arriving in Dade County about 1907 from Georgia, driving her team of oxen and a two-wheeled cart, with her shotgun and dogs in tow for company. She came to Florida after her own husband had been hanged for killing a man. Wearing men's shoes, Sarah plowed fields, cut crossties for the railroad and hauled limestone rock—whatever it took to make a living. Sarah later received a letter from her family, asking her to check on her sister Hannah, who lived on the other side of the state. At that time, there were no roads to take her there, so the story goes that for six weeks she literally hacked her way across Florida. Eventually settling at Long Key, now located in the Everglades National Park, Sarah built herself a shack and farmed the land. Upon hearing that her sister Hannah had been killed at the Watson place, Sarah made her way to Chokoloskee and buried her sister. She later moved on up to Immokalee, some thirty-five miles away, where she built a palm-thatched shack and farmed for a few years. She died in 1919 following a stroke and was buried at Fort Denaud Cemetery.

COPELAND, JEROME AND LEE-CYPRESS

CYPRESS LOGGING INDUSTRY

At one time, Collier County had one of the largest remaining stands of virgin cypress and pine trees in the country. These virgin stands in Collier County had reached heights upward of 130 feet or more. Cypress is a durable and rot-resistant wood, and during World War II it was in heavy demand for manufacturing barrels, packing crates and even coffins.

Lee Tidewater Cypress Company began logging operations in Collier County in 1944 and retired in April 1957, some seventeen years later. Once the largest cypress operation in the world, Lee Tidewater Cypress Company was the only one devoted exclusively to logging cypress. The men, too, have moved on. Lee Tidewater managed a self-contained community at Copeland, creating its own power plant, general store, repair shop and housing for the workers and their families at the height of the logging industry.

Logging is very dangerous work, and the loggers worked long, grueling ten- to twelve-hour shifts that they jokingly referred to as from "cain't see to cain't see"—arriving before the sun came up and leaving way after the sun had set. The men had to keep both eyes open and watch out for one another. Accidents happened in the blink of an eye. In addition to the heat on these daily lengthy shifts, the men had to be watchful of alligators, chiggers, razor-bladed sawgrass and venomous snakes. But the worst condition by far was the water rash, in addition to standing in waist-deep muck on a daily basis.

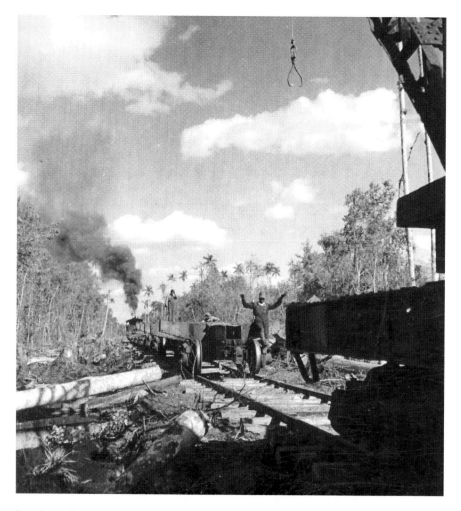

Logging in Lee-Cypress, 1944–57. *Courtesy of Florida State Archives.*

"Logging in Big Cypress posed its own kind of problems, mainly because of its location. Loggers first had to cut their way through thorn-vines that were strong enough to truss a man and tough enough to bounce off a machete. In cypress logging, a man is judged by his worth and not his age. And, it takes a real man to work in water up to the waist and endure water rash," writer Jeanne Van Holmes stated in her 1955 article "The Big Cypress." Harvesting cypress is not an easy task. First, the trees are girdled, or cut completely around, in order to drain the sap, which ultimately kills the tree.

Copeland, Jerome and Lee-Cypress

Naturally, trains go hand in hand with the logging aspect. The Lee Tidewater Cypress Company operated four steam engines through the Big Cypress swamps of the Fakahatchee Strand from 1944 to 1957. These old iron workhorses were perfectly suited to the logging demands in the swamp. Built by the Baldwin Steam Locomotive Works back in 1904–1913, the No. 2 locomotive was designed as a "prairie-type" engine, suitable for running forward or backward.

By the winter of 1956–57, logging had ceased because all of the economically harvestable stands had been depleted. How fitting that the No. 2 engine would end up back here in Collier County after all those trips. How fitting, too, that it found a home at the Collier County Museum headquarters by the government center. You can't miss Old 2, since it's next to the door that heads out onto the museum grounds.

Today, with logging a thing of the past, the sound of the axe is gone—and that's a good thing.

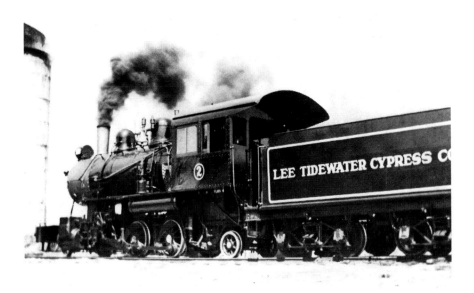

Engine No. 2 used in Lee-Cypress logging, currently housed at the Collier County Museum headquarters in the East Naples Government Center. *Courtesy of Florida State Archives.*

JANES RESTAURANT, COPELAND MARKET AND THE POST OFFICE

Arriving in Copeland in 1929, Dorothy and Winford Janes built and began operating the Copeland Market, post office and Janes Restaurant. The restaurant opened on New Year's Eve 1933 with jukebox music, dancing and 3.2 beer (percent alcohol). Pioneers J.B. Janes and Alfred Webb joined forces with them, along with Winford's brother, Wayne. Tomato farming was the major industry in this area in the late 1920s and early 1930s. At one time, the Winford Janes family was farming anywhere from 100 to 150 acres, mostly tomatoes, in addition to managing their shops. For seventeen years, Winford served as a county commissioner, based at that time out of Everglade. The "s" wasn't added until after the town incorporated in 1953. The Janeses reared their three children, two daughters and one son—who passed away in 1967. Both daughters graduated from Everglade High School.

Located in eastern Collier County, the unincorporated town of Copeland, with fewer than three hundred residents, is located at the junction of State Road 20 and Janes Memorial Scenic Drive (Collier County Road 837).

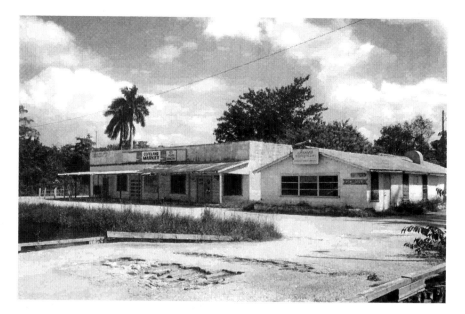

Janes Restaurant, Copeland Market and post office complex that served the local community from 1933 to 2002, when it was razed to serve as additional properties for the Big Cypress National Preserve. *Photo by Marya Repko, ECity-Publishing*

Copeland, Jerome and Lee-Cypress

The small town of Copeland is nestled between the Fakahatchee Strand Preserve State Park and the Big Cypress National Preserve. It was founded in 1921 in honor of the former civil engineer David Graham Copeland, who worked for county namesake Barron Gift Collier on both the establishment of Everglade, the town and the Tamiami Trail. The tiny town of Jerome lies a few miles to the north, with Carnestown located a few miles to the south at the intersection of State Road 29 and U.S. Route 41 (Tamiami Trail).

By the early 1940s, Copeland was a thriving tomato-farming center, complete with a packinghouse. The Atlantic Coast Line Railroad carried crates of tomatoes to markets northward, including both Immokalee and Haines City. At one time, there was a small train station in Copeland. By the mid-'40s, Collier's manager, David Graham Copeland, observed a beehive of activity in the small town. Unfortunately, there were no schools in Copeland, so students had a choice of attending either Everglade or DuPont, and they traveled by bus.

Janes Restaurant was located on State Road 29, roughly six miles north of Everglade; and open seven days a week for breakfast, lunch and dinner, with daily specials. The restaurant was a favorite among local fishermen and hunters. Winford passed in 1962, and the restaurant switched ownership. Because Winford was so well respected, the former Copeland Grade Road was renamed Janes Memorial Scenic Drive following his death. By this time, there was a noticeable shift in local farming, moving over in the direction of Immokalee. In 1975, Dorothy moved to Jacksonville, Florida, where she resided until her death in 1982. In 2002, the former family business complex was purchased by the Big Cypress National Preserve and razed.

COPELAND BAPTIST CHURCH

Just three miles north of the Tamiami Trail on Janes Scenic Drive, and west of State Road 29, lies a small unincorporated community in eastern Collier County, Florida, called Copeland. Copeland was founded in 1932 in honor of David Graham Copeland.

The congregation of Copeland Baptist Church was established in 1935, when nearby Lee-Cypress was a logging camp. The current building was built in 1947 and has undergone several renovations over the years. With the exception of a two-year period during 1956–58, it has been in continuous operation. Upon hearing of the church's closing, Pastor Clyde Martin, with

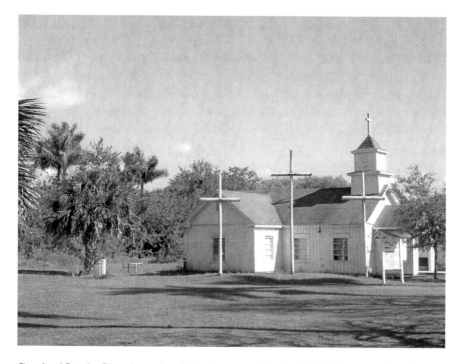

Copeland Baptist Church, serving the local community since 1947. *Courtesy of Collier County Historical Research Center, 2010.*

the help of the First Baptist Church of Fort Myers, reopened the mission and was pastor for nearly thirty-two years, until the Lord called him home in 1990.

Of historical note, Copeland Baptist Mission was the first fully integrated church in Collier County, with Miccosukee Indians, Hispanics, blacks and whites all worshiping together in 1961. Once the integration laws passed, the Bula (pronounced Beu-lah) Baptist Mission, in nearby Lee-Cypress, was closed, and Miss Frances—the local community's designated matriarch, described in the next "Colorful Characters" segment—began attending the Copeland Baptist Mission until her passing in 2007.

Pastor Kingsley Roberts and wife Millie took over following Martin's passing. Arriving in Florida in 1962, the Robertses entered into the ministry in 1968. Both Millie and Kingsley attended the Baptist Bible Institute in northern Florida. Before Roberts entered the ministry, he was a heavy equipment operator at the former Remuda Ranch, today's Port of the Islands. They lived in Bonita Springs but kept a trailer in nearby Lee-Cypress across the street from the mission.

Copeland, Jerome and Lee-Cypress

Several more pastors came and went through the next decade, until Pastor John H. Gilmore arrived in the fall of 2002. Gilmore, a decorated combat veteran, having served in Operation Desert Shield, received a call from his pastor on the annual National Day of Prayer, asking if he could preach at Copeland Baptist Mission one Sunday, and he's been with them ever since. The attendance that first Sunday was four, and within a few years it was up to forty-one; present-day active membership has reached twenty-eight. The community was rife with drugs when he first began, but he has seen the face of the neighborhood change during this time, and he gives all of the credit to God. Gilmore has also done something that previous pastors had not: he moved into the community that he serves—full time, and not just on the weekends, preferring to live with his parishioners while gaining firsthand knowledge of their community.

After Hurricane Wilma hit in 2005, the church was the focal point for emergency services on the other side of State Road 29 from Everglades City, feeding roughly three hundred people per day from a mobile site. Everyone in the small community was on hand to lend a helping hand in the clean-up efforts following the hurricane; the members remain ready to assist whenever the need arises. Today, the church members are all working together for the good of the community.

In February 2008, Gilmore announced that after fifty years the church had broken away from the missions in Fort Myers, Florida, and is now called Copeland Baptist Church.

COLORFUL CHARACTERS

Frances Hodge and the Bula Baptist Mission

As the new reporter in these parts in 1993, I first met "Miss Frances," as everyone called her, one morning as she was literally heading out the door, cane fishing pole in hand. She only had a minute, she told me, because the fish were biting. She did, however, take a few minutes to answer my few questions, and then she was off. Throughout the next year, while working for the *Everglades Echo*, I would see her from time to time. She always had a smile on her face. Even though I would hear or read different stories about her during the next decade, our paths didn't cross again until just about a year before her 100th birthday. I had the privilege of joining several local ladies

to visit Miss Frances in her home to hold an interview, but unfortunately I never wrote the article, and she passed away on August 17, 2007.

What she did share with all of us that afternoon was that she was born on August 22, 1906, in Alabama, in an area commonly referred to as the Black Belt due to its suitability for cotton farming. Her father farmed cotton and other crops. One of twelve children, Miss Frances liked climbing trees and pretty much told it like she saw it, not mincing too many words, right until the very end. She only attended school through the third grade, simply because her family didn't have the money to send her. She told us that she had been married three times—the first marriage only lasting seven days. Sweet potato pie was her favorite, and she told us she makes a mean one. She still believed in folk remedies, putting turpentine near her trailer doors when it's chilly outside to prevent colds. For the past fifty or more years, she had probably babysat just about all the kids in the neighborhood. And she loved to fish.

Miss Frances, and her late husband Monroe, arrived in Copeland in 1950 to work in the booming logging industry of the Lee Tidewater Cypress Company. She woke before dawn to cook sausage and grits for breakfast and then pack lunches for the loggers, before heading off to cook at a boardinghouse. When the logging industry closed down, her husband told her that he was going back to Alabama, and she told him to go on ahead and that she planned to stay here in Copeland where the fishing was good. She has lived alone since then, helping those she can, living by the golden rule and teaching those around her to also "do unto others."

In July 2002, at ninety-four years of age, Miss Frances offered to donate her former church, the Bula Missionary Baptist Church, to the United States Postal Service to be used as a local post office for the small communities of both Copeland and Lee-Cypress. The old church was built for the black community in the early 1940s and was donated by Doug McGoon, who owned the town. Their former local post office closed in November 2001 after the U.S. Department of the Interior bought the land near the Big Cypress National Preserve. And following that closing, residents had to cross the Tamiami Trail en route to the Everglades City post office, four miles away. A contingent of postal officials did indeed make the visit and took lots of photos. Local resident Greg Bee was on hand and told the officials that he recognized that the community itself would have to foot the bill for various repairs, including a leaky roof, floors that slope, the ceiling that had caved in in the back room and an old Australian pine tree that was

Bula (pronounced Beu-lah) Missionary Baptist Church opened in the 1940s. It was donated to Lee-Cypress resident Miss Frances following its closing during integration. *Courtesy of Collier County Historical Research Center, 2010.*

pushing against the wall outside. So far, they have raised $2,000 toward those repairs, according to Jane Bee, president of the town's Water & Sewer Co-op. The biggest concern postal officials had was regarding the structural soundness of the building. The structure and various other issues, including handicapped accessibility, bathrooms and wiring, were discussed with the contingent promising to get back to them with their findings.

On November 20, 2002, Miss Frances dedicated the old church to the community for use as a meeting place, since it appeared that their chances of turning it into a post office looked pretty slim. According to Miss Frances, "I just don't want the old church lost to the community." Several local residents joined Miss Frances in forming a nonprofit corporation called the Frances Hodge Community Center, Inc., and both the land and the building were deeded to the corporation. Initial plans called for the center to be used as a meeting place for adults and children of the Copeland/Lee-Cypress area. Others wanted to see it used as a place where children can meet after school

to work on their homework and studies. Many repairs needed to be made, including the roof and the back room where the roof has caved in, and some checked into costs of these repairs and rebuilding.

The local community of Everglades City paid tribute to Miss Frances at the annual Diamonds Luncheon, honoring local senior women, in April 2006 as part of her 100th birthday celebration. Her surviving brother, Reverend G.D. Green, and his wife were on hand for the celebration, and her brother read a letter to Miss Frances from former president George W. Bush. Miss Frances

Miss Frances celebrating her 100th birthday at the Naples Pier. *Photo taken by* Naples Daily News *photographer David Ahnthotz. Courtesy of* Naples Daily News.

would have many honors bestowed on her over the years for her undying service to her church and community. She served as the grand marshal of the Fourth of July parade in 2006. Miss Frances was the honored guest at the reopening and dedication ceremony of the "new and improved" Everglades City Hall, following the devastation of Hurricane Wilma in 2005. A few months later, the community fêted her on her 100th birthday in August 2006, with several friends taking her to the Naples Pier for a day of fishing, her favorite pastime, and hosting a luncheon.

Miss Frances lived by the golden rule, and she most certainly left her part of the world a much better place than she found it. A celebration of her life was held on what would have been her 101st birthday, August 22, 2007.

Annie Mae Perry, Midwife to Over Five Hundred Children

When I first met Annie Mae Perry—or Mother Perry, as she was commonly called—I couldn't get over the small stature of this woman, made even more pronounced after hearing of her numerous accomplishments at that time. But don't let that small stature fool you for one minute. She may be tiny, but her heart is at least twice her size! And she always had a smile on her face.

Perry was the middle child of five, born to Arthur and Annie (née Perkins) McKinney in Monticello, Florida, a small town twenty-seven miles east of Tallahassee. Her father was a professor who had graduated from Tallahassee College—no small feat in those days, as few blacks managed to attend college. He would later serve as a teacher to his own children in their school.

Perry met her husband, Willie, growing up in the same neighborhood and attending both school and church together. They married when she was seventeen to his nineteen. With wages poor in that area, Willie took a job in the logging camps in Copeland, a small town just outside Everglade, in order to feed his growing family of five children. The year was 1947. She recalls the differences between Naples and Monticello. When they first arrived, black children couldn't attend school past the eighth grade. "We've come a long way since those early days," Perry shared with this author in 1995; she added, "We knew we wanted our children to get an education in order that they would be able to get ahead in this life."

Her grandmother was a midwife and taught her the trade. Perry said during her early years that she would get anywhere from "nothing to three dollars, sometimes five dollars, and up to fifteen dollars, for delivering babies." Perry delivered babies in Everglade, Port DuPont, Copeland,

Annie Mae and Willie Perry moved south to Copeland in 1947 to work at the logging camps. She served as a midwife to more than five hundred babies. *Courtesy of Collier County Historical Research Center, Inc.*

Ochopee and Immokalee, as well as Naples. "I never delivered an Indian; they would deliver their own babies."

Before learning how to drive, the sheriff often drove her to mothers in labor. Toward the end of her midwife career, her fees had increased dramatically to $50; and at one of her last deliveries prior to her retirement in 1972 she was paid $100 for services rendered, the most she'd ever been paid. In her twenty-five years as midwife in Collier County, Perry delivered more than five hundred babies. Black, white or Hispanic—it didn't matter to her; she loved them all. And she loved them so much that she held an annual Children's Day birthday party with cake and ice cream for "all her babies" every second Sunday in June at her church.

In addition to these five hundred babies, she and Willie would have their own five children. These five children brought forth thirteen grandchildren,

who in turn brought forth fourteen great-grandchildren, followed by seven great-great-grandchildren. In 1995, there were five living Perry generations in all, numbering well over one hundred people.

In addition to her midwifery, Perry also drove a school bus in Copeland, picked tomatoes, served meals in the Port DuPont School cafeteria and later babysat children in Naples at the former Fun Time Nursery in town. She was quite an inspiration to the local community, as well as to her own family. Numerous plaques given to her over the years attested to her love of service to others as well as her faith in God. Perry passed in 2008 at ninety-eight. She was truly a mother to everyone.

PART V

OCHOPEE

BOOMING TOWN

Today, while traveling through Ochopee (a Seminole word for "big field") along the Tamiami Trail, it is hard to imagine that this area was once home to more than 1,200 people—it seems so desolate now. But let me take you back in time; imagine if you will as you head east on Tamiami Trail toward Miami and picture in the vicinity of the smallest post office, on the south (right) side of the road, a highly productive packing house. Remember that this was choice tomato farmland during the late 1920s and early 1930s. Now, can you also visualize the Ochopee Café, and right next door was Griff's Garage? In this same vicinity is a power plant, a general store and small cottages where the local workers lived. And in the back of this area stood a mule barn. Keep in mind now that we are talking about the year 1940. The businesses were on the south side of the road, with residential homes on the north side. We have Florida historian Alvin Lederer to thank for the priceless image shown here.

Now some of you old-timers will remember Mama Hokie's cryptic sign "BEER WORMS" that made many people smile while driving past along the Tamiami Trail. Her sign was located on the same side as the local population. Some of those family names include the Griffins, Ralph Brown, James Gaunt, Sidney Brown, Adams and more. You'll recall that it was James T. Gaunt who offered the use of his irrigation shed back in 1953 after a transient truck driver had fallen asleep with his cigarette and the entire place burned down, killing him, too. That was probably the beginning of the end for this town.

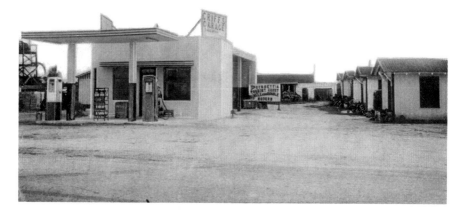

Griff's Garage in Ochopee, circa 1940s. *Courtesy of Alvin Lederer.*

OCHOPEE LANDMARK: HOME OF THE SMALLEST POST OFFICE

Four miles east of Highway 29, from the crossroads at Carnestown, stands the smallest post office in a tiny town called Ochopee, located along the Tamiami Trail in the heart of the Big Cypress National Preserve. While today the "big field" description certainly fits the location, because it is surrounded by lots of empty land, that wasn't always the case. Ochopee actually became a booming town back in the 1930s and through the early 1950s with its packinghouse, restaurant, boardinghouse, garage, general store with a post office, filling station and other buildings, as well as the local workers' quarters. The north side of the Tamiami Trail boasted houses for the foremen and owners, with the south side of the Trail for local businesses. But all that quickly changed in an instant.

A transient truck driver had rented a room in the three-story boardinghouse in 1953, and after dinner at the café he went back up to his room. He had been drinking and smoking and apparently passed out, and the next thing

anyone knew, the building was on fire. The truck driver was burned so badly that he died the next day. Unfortunately, the closest fire department was in Everglades City, seven miles away, but all of the men in the community were running to and from the canal with buckets of water trying to keep it from getting bigger until the fire trucks arrived. Unfortunately, the fire trucks' hoses broke, and everyone had to just stand back and watch it burn to the ground. One building ignited the next one, and so it went. It was a massive fire, but luckily, Sidney Brown, the owner of the general store and postmaster, was able to save his postal records. After the fire, everyone now had to travel to nearby Everglades City for all of their needs. This was probably the beginning of the end of the tiny town, even though in its heyday, Ochopee had more than 1,200 people on record.

The following day, while literally picking up the pieces, the mail came, jolting everyone back to reality—and to the need for a new post office. Local citizen and farmer James T. Gaunt offered the use of one of the irrigation sheds nearby until a new post office could be built, and he shared with the late folklorist Maria Stone in her book *Ochopee: The Story of the Smallest Post Office*: "We can use one of those sheds out in the field that we store irrigation

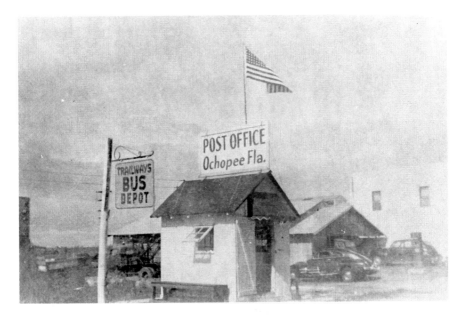

Ochopee Post Office, along the Tamiami Trail, circa 1940s. *Courtesy of Florida State Archives.*

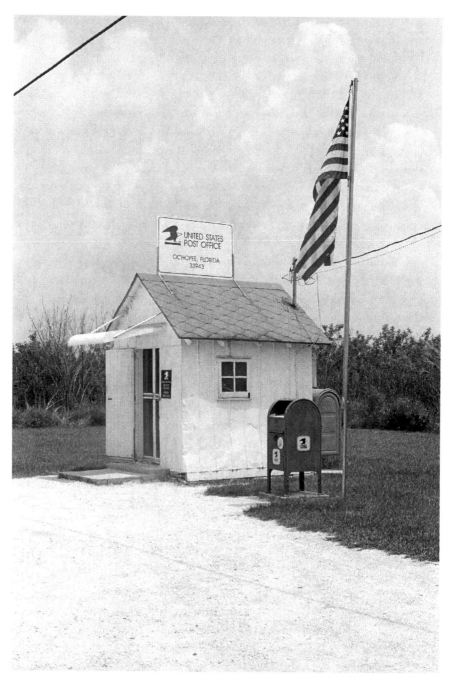

Landmark Ochopee Post Office, fifty years later, taken in mid-1990s. *Photo by author.*

pipe, hoses and things in." And thus was born the Ochopee Post Office, measuring all of its eight feet, four inches by seven feet, three inches. There's only room for one person behind the counter and only one customer at a time. The tiny post office has been home now to six postmasters, beginning with Brown and followed by Barbara Harmon and Evelyn Shealy—who was honored as the Florida State Postmaster of the Year in 1990. Then followed Naomi Lewis, Michelle Smith and now Nanette Watson, who currently serves the postal patrons and is quite happy to postmark visitors' letters from the tiny town. Who knew that this makeshift post office would stand the test of time, and several hurricanes, while becoming a national landmark and tourist attraction along the Tamiami Trail?

COLORFUL CHARACTER

Mama Hokie, aka Clara McKay

For many years after arriving in Naples in 1981, I sped by the sign along the Tamiami Trail in Ochopee and wondered, "What on earth are beer worms?" They certainly didn't sound very good, and I figured it must be some type of fishing gadget; I mean, how would I know, since I'm not a fisherman. But the sign would always bring a smile to my face.

The large cryptic sign belonged to Clara and Sam McKay, and it stood along the Trail outside of their home and business. Sam established a rental trailer camp in the 1950s after moving here from Miami. The trailer camp provided affordable lodging to the growing numbers of campers called tin canners—so nicknamed due to their uncanny resemblance to tin cans—that were now invading southwest Florida in the late 1950s and '60s. These were the forerunners of today's recreational vehicles.

Sam's camp was built on a five-acre clearing of land known as the Ochopee Farms, touted for its rich soil for tomato farming, and it was offered by the Miami Land Company. Sam's trailer camp was in business prior to the formation of the Big Cypress National Preserve, and it housed several wooden dwellings known as chickees. A chickee is a traditional shelter supported with cypress poles, with a raised floor and open sides and then topped with an A-framed thatched roof made from cabbage palm fronds. Following his death in 1966, Clara continued to run the business, which now also offered various sundries, as well as beer and worms. And as traffic

"Beer Worms" sign along the Tamiami Trail, owned by Clara and Sam McKay. *Photo by Maria Stone. Courtesy of Collier County Historical Research Center, Inc.*

increased, so did Clara's reputation and warm hospitality, endearing her to many while also earning her the nickname of Mama Hokie. The landmark roadside sign continued to bring travelers to her door for more than thirty years while also keeping her company.

At eighty-one years of age, Mama Hokie nearly died after walking out onto her wooden bridge over the canal to dump a bucket of water. An alligator came out from under the bridge and grabbed Hokie by the arm. She frantically fought him off while hanging onto the bridge for dear life. The nightmare struggle finally ended when she realized that half of her right arm had been twisted off by the alligator. Miraculously, she managed to call 911 before passing out on the bridge. It would take thirty minutes before the medical helicopter arrived, finding her conscious (even though officially she had bled to death). Paramedics managed to resuscitate her as they sped to the hospital. Within an hour of the attack, Fish and Wildlife officials had located the gator, since it was still close to the bridge. Even though her lower arm and hand were retrieved, they were too mangled to reattach. Following five months of therapy and recuperation, Hokie returned home to Ochopee and continued her remarkable lifestyle with the help and support of her

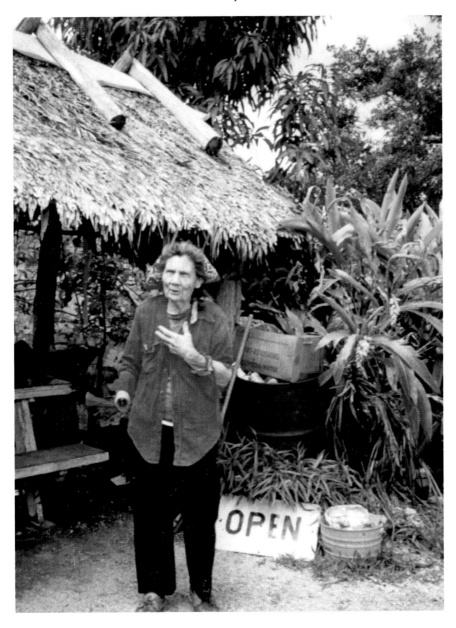

Mama Hokie lived along the Tamiami Trail in Collier County. *Photo by Maria Stone. Courtesy of Collier County Historical Research Center, Inc.*

friends, neighbors and her church. The freak accident required her to give up her worm farm business—that of raising fishing worms—because it was just too hard to work with one hand, even though she did finally master writing with her left hand.

Five years later, during Tropical Depression Jerry in 1996, Mama Hokie suffered another life-threatening experience. The canal had overflowed, and the rising waters were rushing toward her home. She awakened in the middle of the night and discovered six inches of swamp water inside her home. She stumbled while wading across the room in order to escape and fell to the flooded floor. Unable to right herself, she struggled to keep her head above the foul water throughout the rest of the night. Fortunately, a park ranger came looking for her the following day and found her, barely lucid and protesting the need to go to the hospital. After passing out, she was rushed to the hospital, where she was treated for the next three weeks; this was followed by two weeks of recuperation at a friend's home before she was finally able to return home. Sadly, Hokie never fully recovered from this last incident. The combination of her lengthy exposure in the water and the ingestion of swamp water, in addition to her age, had caused pneumonia to set in, requiring Hokie to return to the hospital for three more weeks. This additional hospitalization took its toll on her, leaving her weak and unable to live alone ever again. After her release, Hokie briefly lived with another friend before reluctantly being moved into a nursing home for proper care. With her health declining quickly, Hokie died on December 16, 1996—of a broken heart and body, so the story goes.

BIBLIOGRAPHY

Bristol, H.L. "Importance of Port DuPont to the Success of the Tamiami Trail." *Collier County News*, April 26, 1928.

Brown, Loren "Totch" G. *Totch: A Life in the Everglades.* Gainesville: University Press of Florida, 1993.

Chokoloskee Church of God. *Reminiscing the Past: Chokoloskee Church of God Celebrates 85 Years.* Commemorative Booklet. Everglades City, FL: self-published, May 1998.

Collier County News. "Pioneer County Writer Told World of Chokoloskee's Troubles & Fun." February 6, 1953.

Collier County Sheriff's Office website. http://www.colliersheriff.org/Index.aspx.

Douglas, Marjory Stoneman. *The Everglades: River of Grass.* Sarasota, FL: Pineapple Press, 1947.

Everglades Area Chamber of Commerce special supplement (Winter 1986–87).

Everglades City High School. "Attractions of the Western Everglades." *Prop Roots.* Vol. IV. Everglades City High School, 1987.

Everglades Community Church. *Everglades Community Church Celebrates 80 Years*. Commemorative Booklet. Everglades City, FL: self-published, January 2006.

Everglades Echo. Commemorative edition for 100th anniversary, July 1, 1993. Compilation of articles written over the years.

Friends of the Museum of the Everglades. *Historic Buildings Around Everglades City, Walking Tours*. Everglades City, Florida, 2006.

Holmes, Jeanne Van. "The Big Cypress." *American Forests* 61 (1955).

Ivey House marketing brochure. Everglades City, Florida.

Ivey House website. www.iveyhouse.com.

Jamro, Ron. "The Amazing Adventures of Mrs. W.R. Maynard." *Naples Daily News*. Millennium special, December 12, 1999.

———. "The Amazing Career of Barron Collier, the Father of Collier County." *Naples Daily News*. Millennium special, 1999.

———. "Copeland Remembered for East Trail, Everglades City." *Naples Daily News*. Millennium special, May 30, 1999.

———. "Hurricanes Are Violent Part of County's Colorful Past." *Naples Daily News*. Millennium special, June 6, 1999.

———. "World War I Aviator Was County's First Lawman." *Naples Daily News*. Millennium special, July 25, 1999.

Leen, Jeff, and Carl Hiaasen. "Marijuana Bust Nets 28 in Collier." *Miami Herald*, July 8, 1983.

Maddox, Jennifer. "A Swamp Park Is Born: 50th Anniversary." *Naples Daily News*, December 6, 1997.

McIver, Stuart. *On Chokoloskee, Each Man Was an Island.* Glimpses of South Florida History. Miami: Florida Flair Books, 1988.

———. "Star Stuck in the Glades Bucked up by Moonshine and Undaunted by Mosquitoes, Gators and Snakes: Hollywood Movie-Makers Came to Work Their Magic." *Sun Sentinel,* July 28, 1996.

———. *True Tales of the Everglades.* Miami: Florida Flair Books, 1989.

Meek, Dan. "Church May Be Center." *Everglades Echo,* November 20, 2002.

———. "Everglades Echo Founder Remembered." *Everglades Echo,* August 27, 2002.

Miami News. "Glades Film Amazes 'Prop' Man." July 20, 1958.

Naples Daily News. Visitor's Edition, March 1983, 6E.

Philcox, Phil, and Beverly Boe. "The Ox Woman." *The Sunshine State Almanac and Book of Florida-Related Stuff.* Sarasota, FL: Pineapple Press, 1999.

President Harry S. Truman speech at the Everglades National Park dedication, December 6, 1947. The American Presidency Project. http://www.presidency.ucsb.edu/ws/index.php?pid=12798.

Repko, Marya. *A Brief History of the Everglades City Area.* Everglades City, FL: ECity Publishing, 2001.

———. *A Brief History of the Fakahatchee.* Everglades City, FL: ECity-Publishing, 2009.

Roux, Quentin. "Angel of the Swamps." *Naples Daily News,* July 27, 2009.

Rupsis, Rusty W. *Everglades Echo,* vol. 8, no. 31, May 14, 1987.

———. "How It All Started—Seafood Festival." *Everglades Echo,* vol. 4, no. 16, February 3, 1983.

———. "Operation Everglades, Phase II Arrived as Promised." *Everglades Echo*, vol. 5, no. 38, July 5, 1984.

———. "Scenes from Everglades History." *Everglades Echo*, February 1982.

St. Petersburg Times. "Gator Got Her Arm, Not Spirit." September 8, 1992.

———. "Modern Highways Cut 'Glades 36-Day Run to 24-Hour Run." December 11, 1927.

Stone, Maria. *Ochopee: The Story of the Smallest Post Office*. Naples, FL: Butterfly Press, 1989.

———. *We Also Came, Black People of Collier County*. Naples, FL: Butterfly Press, 1992.

Sullivan-Hartung, Maureen. "Along the Trail...and Back in Time with Deaconess Harriet Bedell." *What's Happening Around Town*, October 2005.

———. "Along the Trail with Pastor Jim Gilmore." *What's Happening Around Town*, May 2005.

———. "Black History Month: Annie Mae Perry." *Mature Lifestyles*, February 1995.

———. "Book Ready for Release." *Everglades Echo*, September 25, 1993.

———. "'End of the Trail' Store." *Everglades Echo*, July 29, 1993.

———. "Museum of the Everglades: From a Laundry to a Chronicler of 'The Last Frontier.'" *Florida Living* (August 1999).

———. "New Book Tells of Author's Colorful Life." *Senior Times*, November 1993.

———. "On the Banks of the Everglades: Everglades City's Bed & Breakfast Inn." *Florida Living* (November 1999).

———. "Rebuilding in Everglades City Following Hurricane Wilma." *Florida Living* (December 2006).

———. *A River Runs Through Them...Portraits of Everglades Pioneers, A.C. Hancock*, The Everglade Magazine, Commemorative Issue, April 2, 1997, Issue No. 14, p. back.

———. "Totch Brown: Life on His Own Terms in Florida's Last Frontier." *Florida Living* (March 1999).

Tebeau, Charlton W. *Florida's Last Frontier: The History of Collier County.* Miami, FL: University of Miami Press, 1957.

———. *Reminiscences of C.S. "Ted" Smallwood: The Story of the Chokoloskee Country.* Miami: Florida Flair Books, 1955.

———. *The Story of the Chokoloskee Bay Country.* Miami, FL: Florida Flair Books, 1955.

Tenney, Frank F., Jr., Colonel (USAF Ret.). "Across the Everglades with the Trail Builders." *The Collier County Heritage Commemorative.* Edited by Henry R. Hoffman. Naples, FL: Heritage Publishing and Henry R. Hoffman, circa 1976.

———. "Everglades' Greatest Day." *The Collier County Heritage Commemorative.* Edited by Henry R. Hoffman. Naples, FL: Heritage Publishing and Henry R. Hoffman, circa 1976.

Turner, Gregg M. *Images of America: Railroads of Southwest Florida.* Charleston, SC: Arcadia Publishing, 1999.

Walker, James Lorenzo. "Dedication Speech for 30-Year Anniversary of the Tamiami Trail," June 7, 1958. Delivered at a luncheon at the Rod & Gun Club in Everglades City on the occasion of the dedication of a marker by the Historical Association of Southern Florida. Historical Museum of Southern Florida, Tequesta Archives, X1X (1959). www.hmsf.org.

Wares, Donna. "Small Town Angry After Another Blow, Everglades City Shaken By Busts." *Miami Herald,* July 1, 1984.

Zagier, Alan Scher. "Orchid Illusion: Film Skirts Fakahatchee for L.A. Sensibility." *Naples Daily News*, May 13, 2001.

Zeitlin, Janine. "Copeland Resident Wants to Donate Church for Town Post Office." *Naples Daily News*, July 25, 2002.

About the Author

A yearlong stint as a reporter for a weekly newspaper in 1993 forever changed the path of Maureen Sullivan-Hartung. She was given Everglades City as one of her weekly assignments, and thus began her love affair with this region. Week by week, while making her rounds throughout the community, she garnered new friendships and, little by little, was able to gain the locals' trust. Who knew that this reporting assignment would bring a paper route with it—at the ripe old age of forty? Not only did she gather information while there, she also delivered papers and picked up the old ones and the change from each of the small containers around town. This was yet another fascinating experience of writing for a small-town weekly newspaper that unfortunately is no longer published. The mosquitoes, or swamp angels, whatever you call them, loved her presence down there, especially after an afternoon rain, which it seemed to her was every Wednesday during that year. Within a few months after being hired, she would meet the late Totch Brown, who took her out in the Ten Thousand Islands on that very first interview, which cinched her feelings for the small community. What an experience for a rookie reporter—one that she'll certainly never forget. Many of her previous articles written more than a decade ago were the beginnings of this book. Even after leaving the newspaper, Sullivan-Hartung continues to pitch stories to various magazines and editors on this historic area, wanting everyone she meets to learn about this fascinating region called the Last Frontier. This is her first book for The History Press.

Visit us at
www.historypress.net